IMAGES
of Wales

AROUND
NEATH
THE SECOND SELECTION

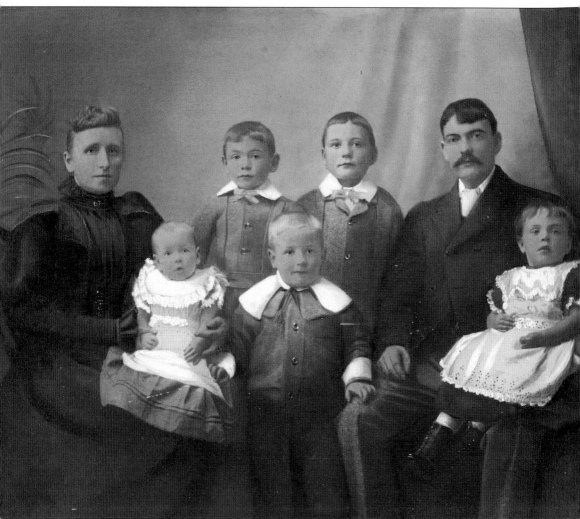

The family of Jenny and Rees Broome who were landlady and landlord of the King William The Fourth public house in Neath in 1898. The pub, which was located in the Green where the cattle market is now held was demolished around 1958. Left to right, at the back: Jenny, Charles, Bertie (who was killed in the First World War during the landing at Gallipoli), Rees (who died in 1901 from tuberclosis). At the front: Martha, Thomas, Nelly.

IMAGES
of Wales

AROUND
NEATH
THE SECOND SELECTION

Bryan King and Robert King

TEMPUS

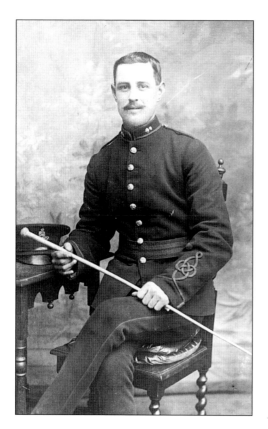

William Richard Powis, seen here around 1917, who was born on Bryncoch Farm and later lived at Brynglas Terrace (now part of Main Road), Bryncoch. He served in the First World War in the Royal Horse Artillery and was one of the only two men in Bryncoch to receive the Military Medal, the other being John Jenkins.

First published 1999, reprinted 2005

Tempus Publishing Limited
The Mill, Brimscombe Port,
Stroud, Gloucestershire, GL5 2QG
www.tempus-publishing.com

© Bryan King and Robert King, 1999

The right of Bryan King and Robert King to be identified as the Author of this work has been asserted in accordance with the Copyrights, Designs and Patents Act 1988.

British Library Cataloguing in Publication Data.
A catalogue record for this book is available from the British Library.

ISBN 0 7524 1817 3

Typesetting and origination by Tempus Publishing Limited.
Printed in Great Britain.

Contents

Acknowledgements

We would like to thank the following for lending us pictures and supplying us with information for the making of this book: Bill Absalom, Stephen Absalom, Cynthia Betts, David Davies, Glyn Davies, Maud Davies, Mike Davies, Trevor Davies, Will Davies, W.J. Davies, Cheryl Denyer, Peter Denyer, Ann Doran, Richard Dyer, Richard Evans, Terry Evans, Ian Gamble, Elizabeth George, Emys Gough, Barbara Griffiths, Richard Hawksworthy, Vernon Hopkins, Mrs Barbara Jones, Peter Jones, Brian Lee, Martin Maggs, Barbara Mellin, Mary Mochrie, Elizabeth Mort, Wilfred Mort, Desmond Orpwood, Roger Place, Malcolm Powis, Alan Price, June Price, Dai Pugh, Kester Reason, W. Scaplehorn, Mrs Snow, Kathryn Smith, Peter Smith, Glyn Thomas, Clive Trott, Vale of Neath Railway Society, Julie Watkins, Dennis Williams, Gerald Williams, Gwyneth Williams.

Introduction

One of the great delights of being involved in a project such as this is that it brings us into contact with others who share our passion for Neath and its past. People's enthusiasm and pleasure is often immense and they will readily dig into all sorts of photograph albums, some of which belonged to grandparents. Fascinating images come to light, many that are of great historical interest, such as the picture belonging to Peter Smith which depicts the landlord and his family of the King William the Fourth public house (see p. 2); added to this the picture was until now unpublished.

Bryan's personal collection was the source of various material that reflects Neath's transport history, particularly of the steam driven variety. There is a rare poster setting out the schedule for the train journey from Neath to Brecon which carried Madam Patti's wedding guests, again, unpublished until now. The pictures of the interior of the GWR garages in Cadoxton will provoke nostalgic thoughts for many who remember the days when there were several bus companies vying for business. These included Western Welsh, United Welsh and the South Wales, all of which worked the roads in and around Neath. Private firms like Creamline all added to the colour of the bus industry when cars were few and the buses were 'standing room only'. The colliers' train from Crynant, with a platform full of people, makes one look to see if a relative might be standing there among the waiting passengers.

The book is filled with pictures of the people and the places of Neath. Some are familiar images, but some are views or occasions long since forgotten. Many people might be surprised to hear that in the sport of horse racing the Vale of Neath once was home to 'Air Queen' one of the most prolific winners ever to have graced the turf. Air Queen's home was firstly Glynneath then Resolven. She won 100 races in the late 1940s and early 1950s, although no book in this area has previously recorded the fact. Thanks to Roger Place's response to a newspaper article, memories of both the horse and her jockey, Bill Carey, are saved for posterity. The horse's trainer, Vernon Place, is pictured holding her head after a win (see p. 96). We sincerely hope that the memory of this and, indeed, every other item published here will bring pleasure to readers.

The response to our requests for photographs for this book has been amazing. Only a small selection are carried here and so we offer our apologies to those who so willingly trusted us with their family records, but whose pictures could not be used. We offer our apologies too, to those we may have inadvertently omitted from the acknowledgements.

Bryan King and Robert King
Abergarwed 1999

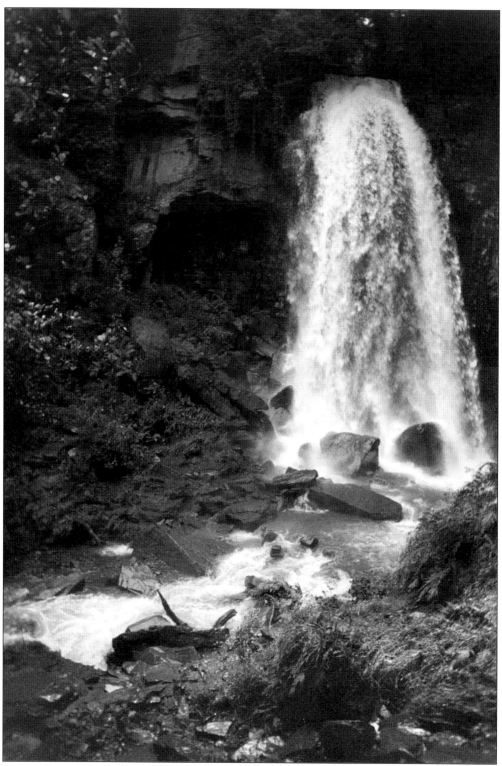

Melyn Cwrt waterfall which epitomizes much of the romance and beauty of the Vale of Neath.

One
Scenes of Neath

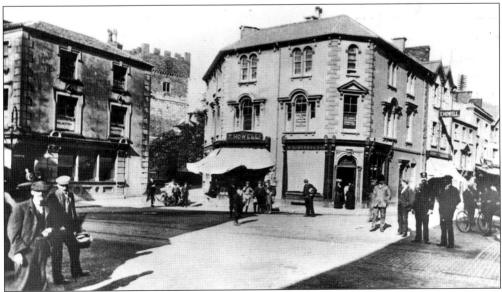

The Square, Neath, *c.* 1900. The lane leading from the Square to St Thomas' church is still used and, although the frontages have changed, the buildings themselves are much the same as they were a hundred years ago.

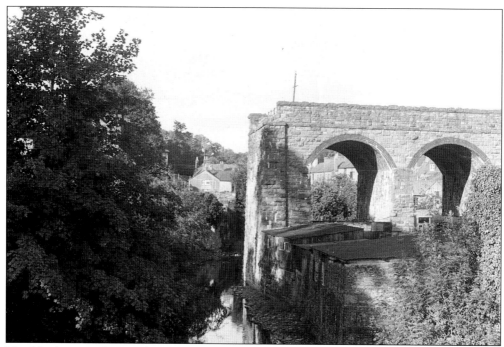

Neath's changing face in the 1960s. This viaduct, seen during demolition, carried the railway from Neath to Neath Junction and the Neath Canal is seen in the foreground. This site is now occupied by Safeway's supermarket.

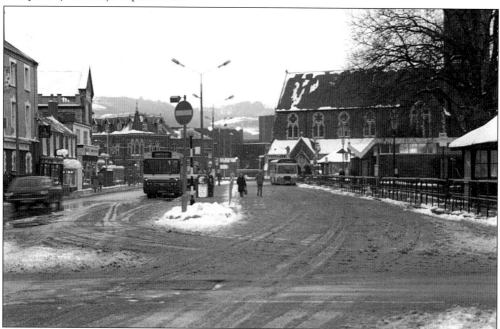

A late 1970s snow scene at Orchard Street and the Victoria Gardens bus terminal. Caught on camera are two buses of Randy Davies' Creamline fleet which ran services from Neath to Pontrhydyfen and Tonmawr; and from Neath to Longford. Their garage was in the village of Tonmawr. Creamline was considered to be one of the better private bus operators.

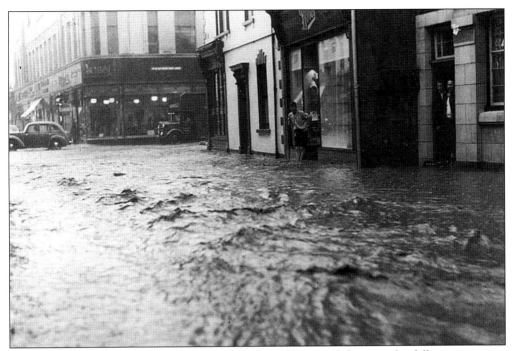

Flash floods in the 1950s. These affected Neath in dramatic fashion as the following pictures illustrate. This is Wind Street looking towards The Square and Green Street. The two men are standing in the doorway of the Three Cranes public house.

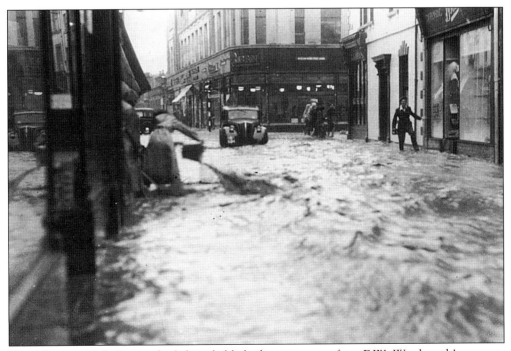

Wind Street with ladies on the left probably bailing water out from F.W. Woolworth's.

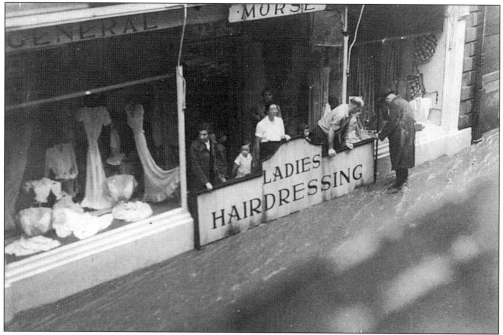

Morse's dress shop during the floods in the 1950s. They had taken down a sign to try and stop the water rushing into the shop.

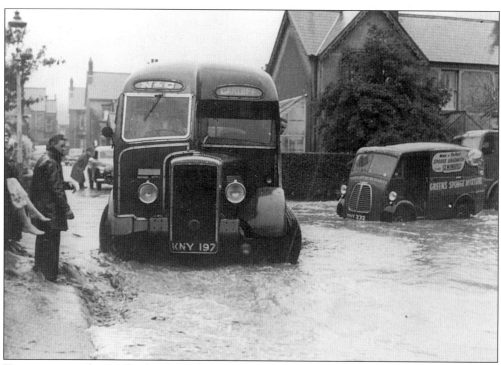

Transportation during the floods. Did this N&C (Neath & Cardiff) coach ever make it to its destination? The van on the right belonged to Jones' General Grocers on Angel Street.

The fashionable Phillip's shop (right) opposite Burton's. Note the sign indicating the dancehall. Immediately on its left is the Machworth billiard hall.

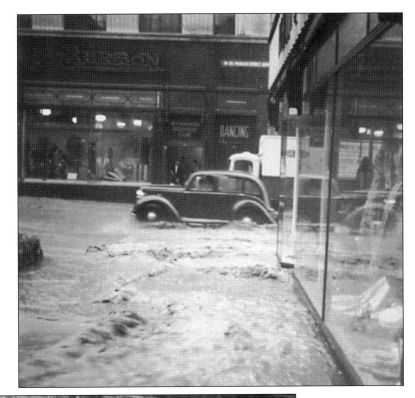

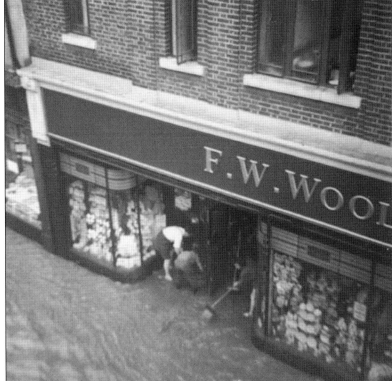

Sweeping water out of Woolworth's onto Wind Street. This picture was taken from an upstairs window opposite.

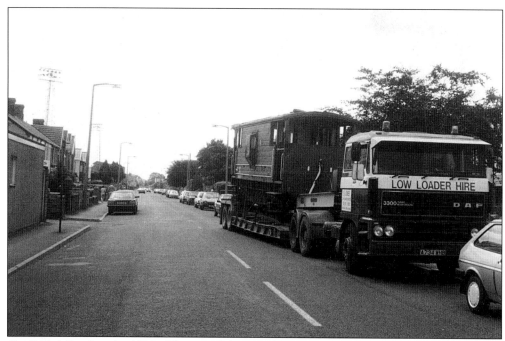

Gnoll Park Road in the 1980s. The now defunct Vale of Neath Railway Society is in the process of moving a brake van.

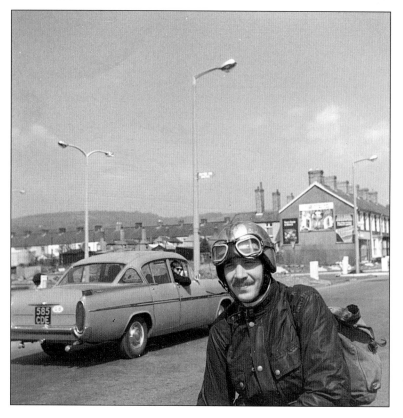

At the junction of Gnoll Park Road and Prince of Wales Drive, 1960s. The houses (centre) are the backs of Rosser Street. The motor cyclist is Peter Denyer and the driver of the car is Martin Davies. Just out of shot to the right was the Civic Centre.

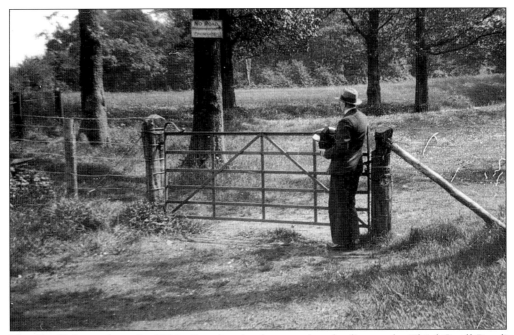

The Gnoll Grounds in the 1920s. Standing by the gate then leading to the Third Gnoll Pond' is Charles Reginald Cottle. If Mr Cottle had proceeded he would have been trespassing as the sign reads 'Trespassers will be Prosecuted'. This entire area now is in public ownership.

Cimla Common from the junction opposite the fire station, c. 1952. In the centre of picture is an air raid shelter which was used later as a bus shelter.

A scene from Cefn Saeson Fawr Farm on the Cimla, in the early 1950s. The picture depicts hay making, but is particularly noteworthy because this area is now covered with houses.

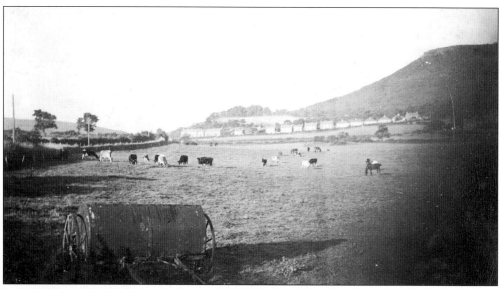

Longford Farm, Neath Abbey, in August 1947. To the right in background is the highest point on the Drummau Mountain and centre is Penshannel. On the left of picture is a lane and beyond that the field where Rhydhir was built and is today.

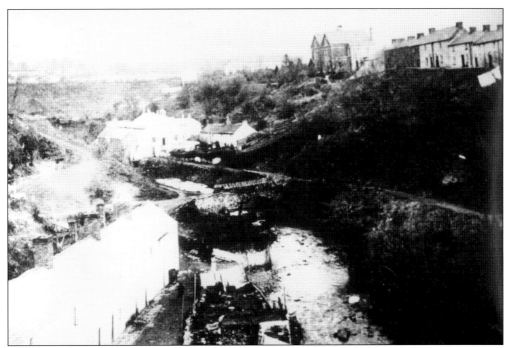

The Cwm, Neath Abbey, in the 1920s. The woollen mill can be seen in the centre and the houses to the right are on Taillwyd Road.

Frederick Place, Lonlas, 1908.

School Road, Jersey Marine, *c.* 1900. Initially called Gorvett's Row, this road first changed its name to Woodlands Terrace and later to School Road. George Gorvett, who lived at Pant-y-Sais Farm, built the first ten houses on what became School Road for members of his family.

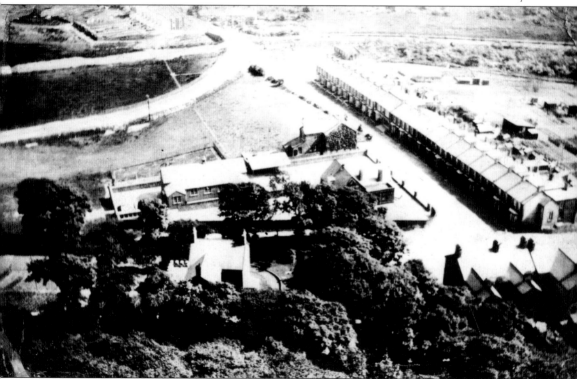

An overview of Jersey Marine, *c.* 1920. Note that New Road's house had yet to be built and construction of Ashleigh Terrace was some years in the future.

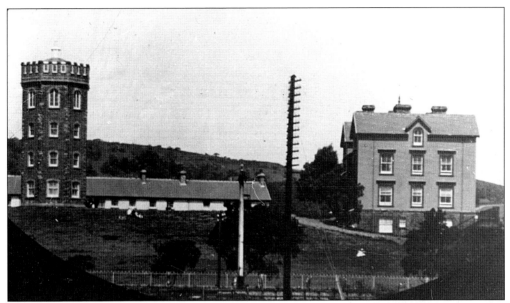

The camera obscura at Jersey Marine, 1930. Part of the Jersey Marine hotel complex, it was built in 1864 by John Taylor of Neath for Captain Evan Evans. The camera obscura was at the top of the tower and, through lenses fitted into the roof turret, a picture of the surrounding countryside in natural colour, was reflected onto a table screen in the centre of the darkened room. Also built into the hotel complex was a full sized 'fives court'; part of which still exists. A plaque on the back of the wall bears the inscription 'Gwrol Galon Hyd Augue' which translates to 'Brave Heart Till Death'.

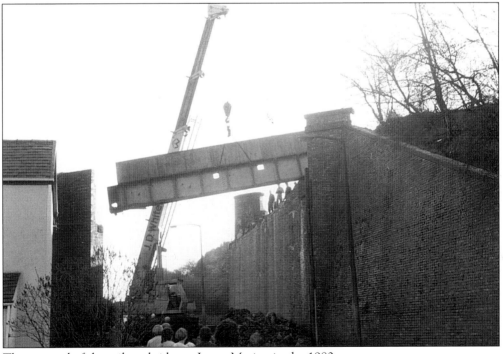

The removal of the railway bridge at Jersey Marine in the 1980s.

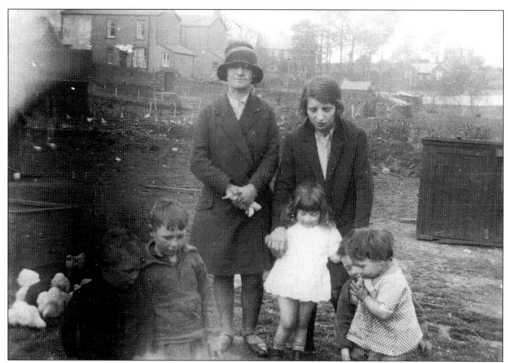

A family view of the occupants of Tonnau Farm, 1928. This farm stood approximately on the site presently occupies by Tonnau Hospital. Left to right, back row: Babs Price, Amy Morgan. Front row: Winston Price, William Price, Mona Price, Cytil Price (obscured), June Price.

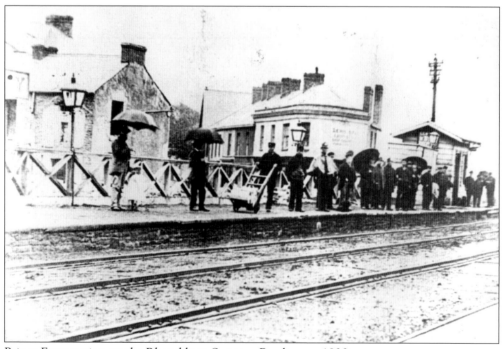

Briton Ferry station on the Rhondda to Swansea Bay line, *c.* 1930.

A view Aberdulais, *c.* 1930. It has changed a great deal with the coming of the new A465. On the right is the post office and along the road is London House followed by the chapel. On the left one can make out the OAP's hall.

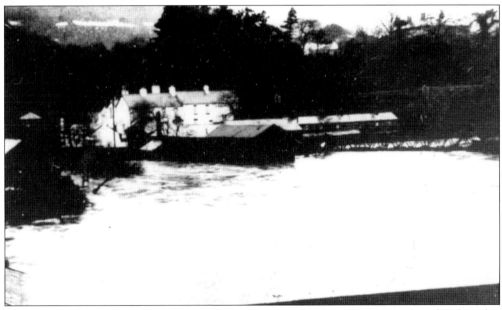

Flooding at Aberdulais, *c.* 1910. Due to the confluence of the canals, the Neath and Dulais, this village is no stranger to floods and is sometimes known as Little Venice. This one affected much of the village including Dan-y-Graig House in centre.

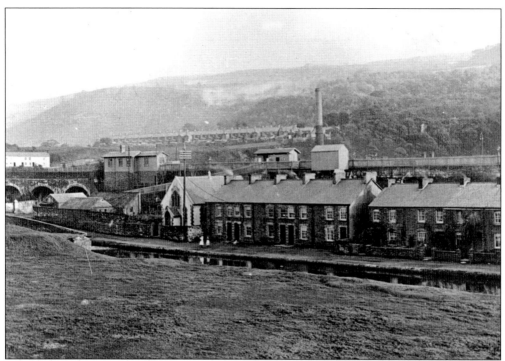

Aberdulais, *c.* 1930. Canal Bank is in the centre with the railway station behind and the stacks of the tin works.

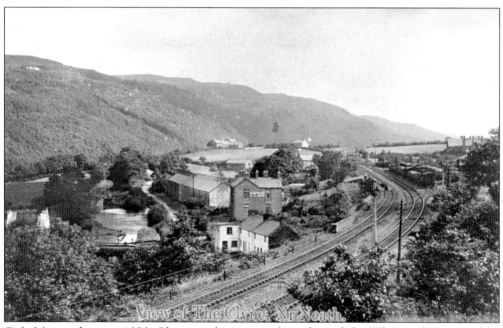

Cefn Mawr sidings, *c.* 1930. Clyne can be seen to the right and the Whitworth Arms public house is in the centre, followed by Cyd Terrace. Cefn Gelli Farm can be seen through the trees.

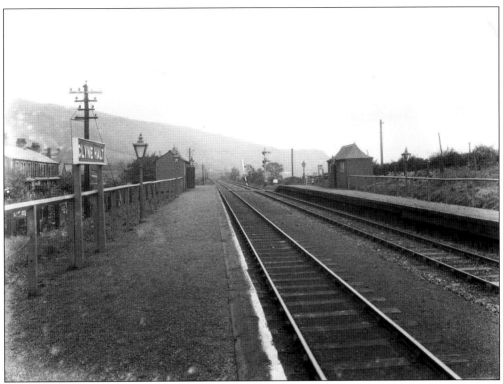

Clyne Halt looking towards Neath in September 1926. On the right are the houses in Heol y Nant.

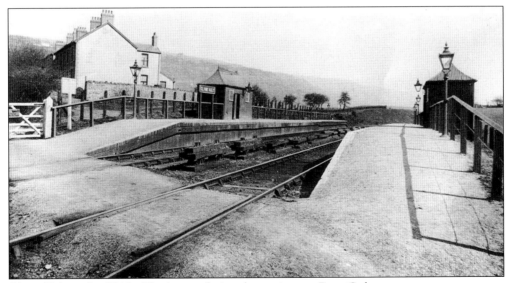

Clyne Halt in the 1940s. The houses facing the station are Bryn Golwg.

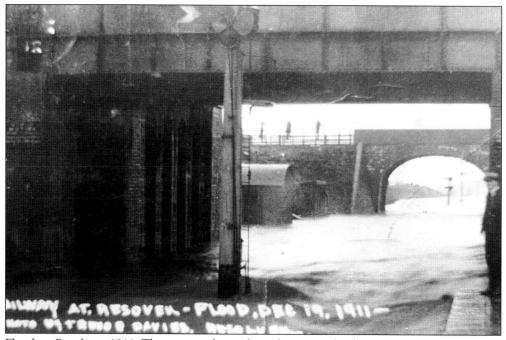

Floods at Resolven, 1911. This picture shows the railway completely under water.

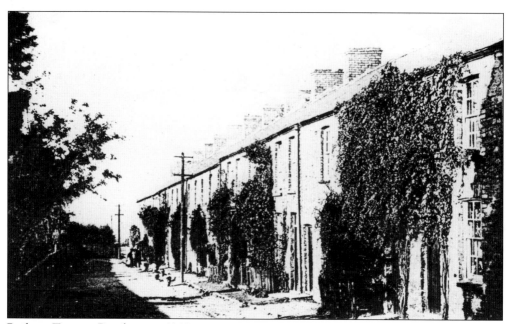

Railway Terrace, Resolven, c. 1910.

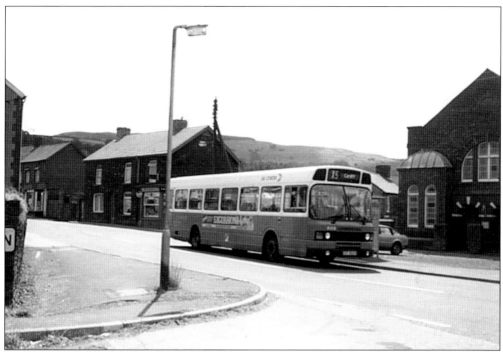

A bus opposite Sardis chapel, when the bus service went to Cardiff from Resolven in the 1980s.

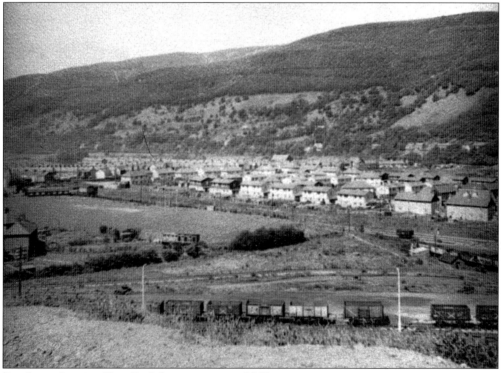

Resolven, showing Ynys Fach housing site, in 1960.

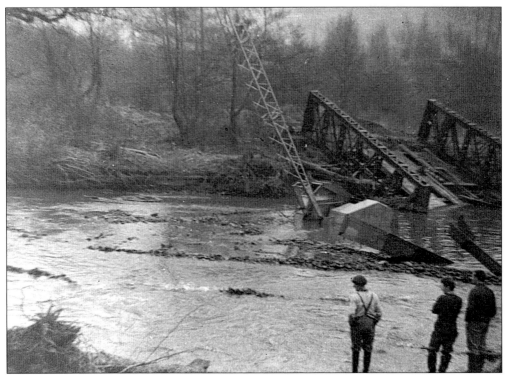

The collapse of the bridge at Abergarwed in 1965. The bridge had once carried a mineral line across the River Neath. However, by the 1960s the elements had destroyed the bridge's superstructure. Attempts were made to save the bridge. A crane was brought in to try and lift it out of the water, but this, too, was claimed by the elements. A footbridge now spans the river at this point.

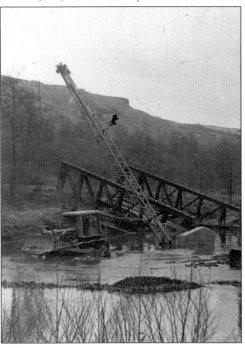

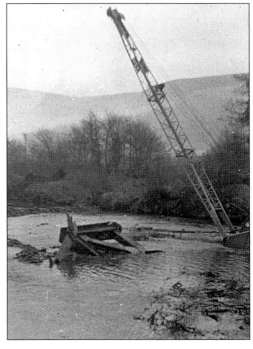

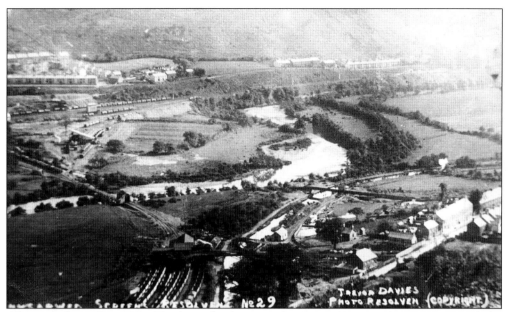

Abergarwed, in the 1930s. To the right foreground is Lewis Terrace, Stag Terrace and the houses on Neath Road. The screens are to the left and Melyn Court in background.

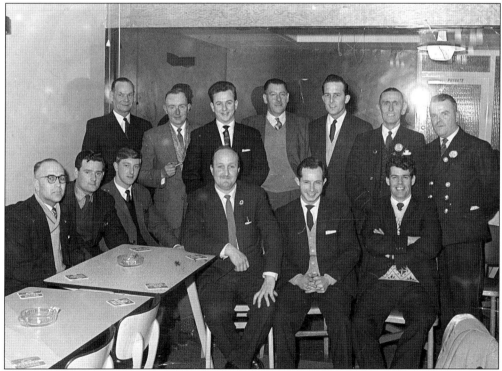

Staff of the Western Welsh bus company in Neath, c. 1964. Included are: F.C. Hamond, Cliff Davies, Arthur Wiltshire, Eynon Evans, Terry Pullman, Mike Gurwen.

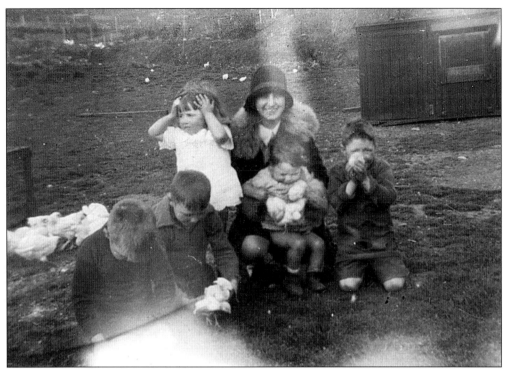

Tonnau Farm, 1928. Left to right, back row: Mona Price, Kitty Morgan. Front row: Winston Price, William Price, June Price, Cyril Price. The subjects in the picture are nursing chicks.

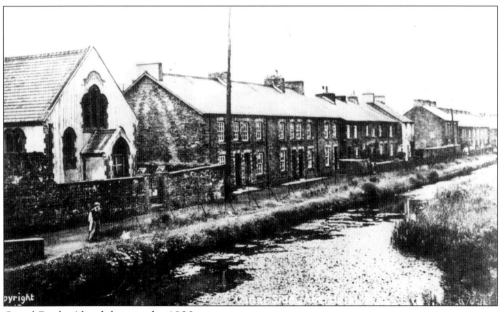

Canal Bank, Aberdulais, in the 1920s.

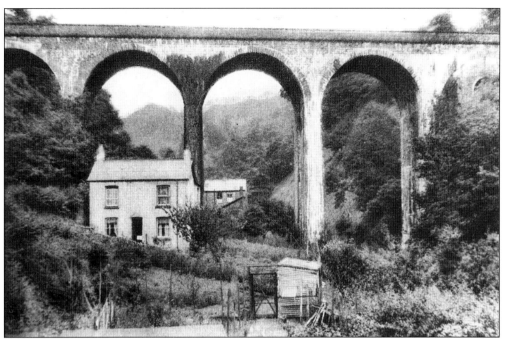

Pontwalby viaduct, a Brunel construction, in Glynneath, *c.* 1870.

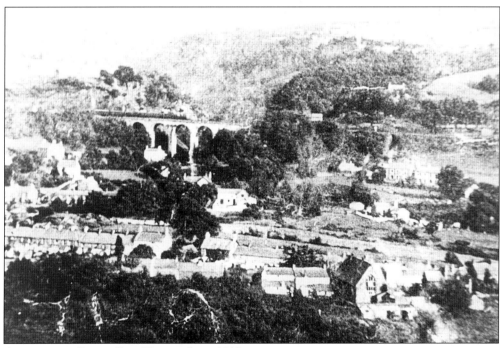

An view over Pontwalby, Glynneath, *c.* 1910.

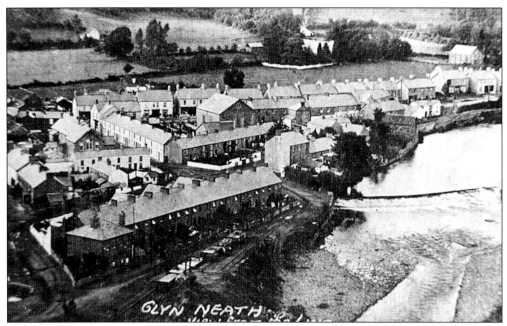

Glynneath, *c.* 1920. The entrance to a tunnel which used to carry water underneath the houses to the canal can be seen centre right.

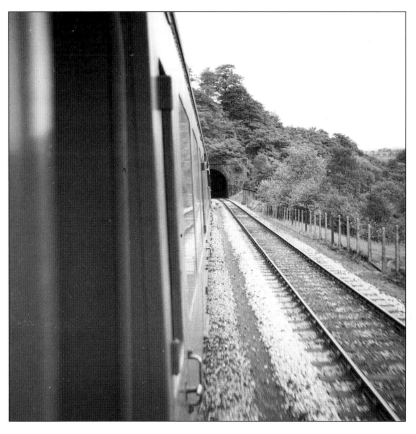

A train approaching Penycadrain tunnel, Glynneath, *c.* 1950. This tunnel was on the rail link between Glynneath and Rhigos. The new A465 now bisected the rail link but one of the tunnel mounts can still be seen.

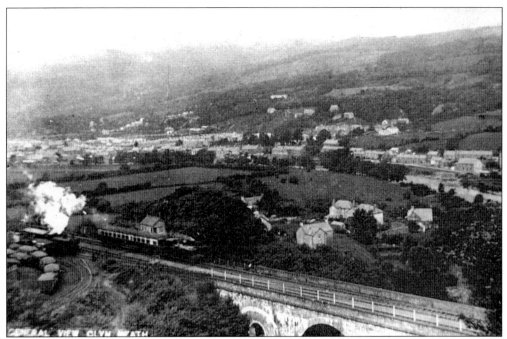

Pontwalby viaduct and Pandy colliery, *c.* 1940.

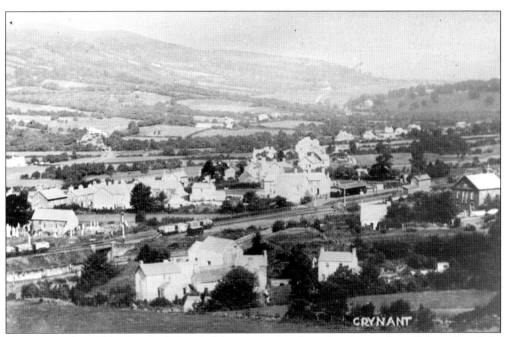

Crynant in the 1920s. On the left is St Margaret's churchyard and on right is Salem chapel. In the centre is the railway station.

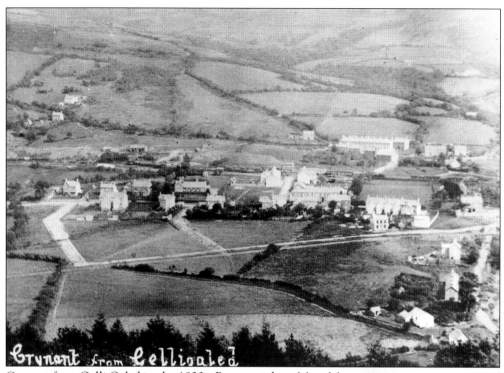

Crynant from Gelli Galed in the 1920s. Bottom right is Maes Mawr.

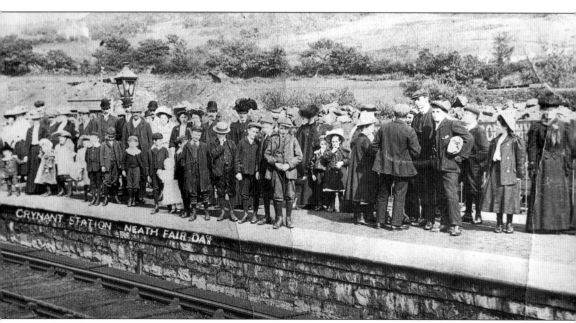

A gathering on Crynant station for a visit to the Neath September Fair in 1910.

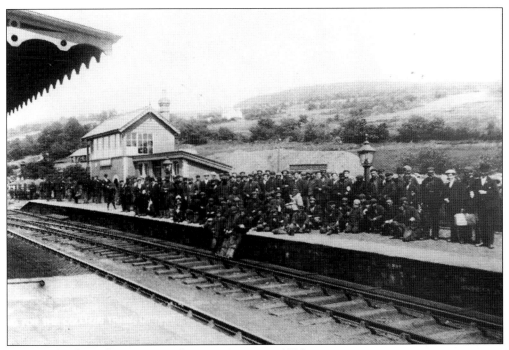

Waiting for the colliers' train at Crynant station, *c*. 1920.

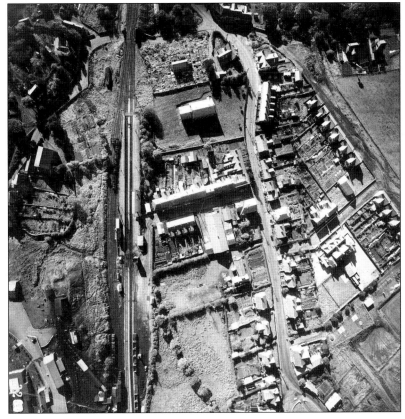

An aerial view of Crynant, 1950. The Square is at the top with St Margaret's church below and Salem chapel on the right. Centre right is the Neath & Brecon railway.

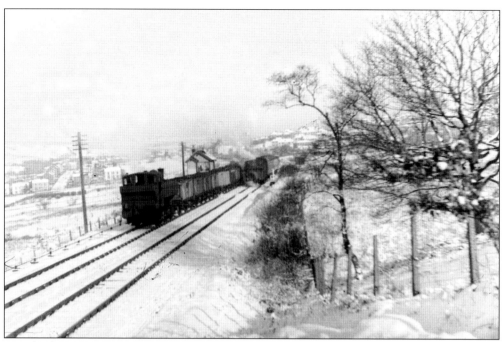

Ynysdawley Loop, Seven Sisters, *c.* 1960.

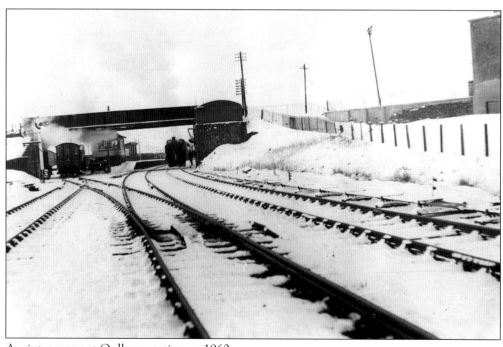

A winter scene at Onllwyn station, *c.* 1960.

Two

Transport

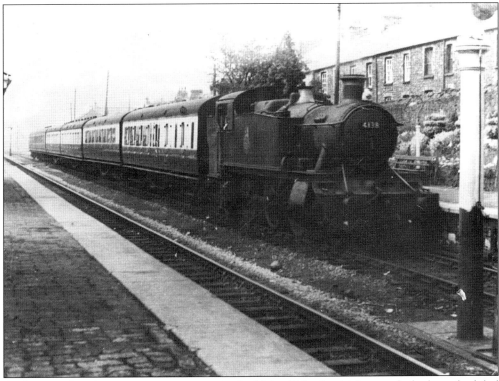

An historic shot depicting transportation in the Vale of Neath which records the last scheduled passenger train out of Resolven. This one is bound for Pontypool Road in 1960.

SOUTH WALES & VALE OF NEATH RAILWAYS.

CHEAP
EXCURSION ᵀᴼ LONDON.

On MONDAY, AUGUST 7th, 1854,
A
SPECIAL TRAIN
WILL LEAVE
HAVERFORDWEST ꜰᴏʀ LONDON,

Calling at the undermentioned Stations ; and will return from the Paddington Station on
Saturday, August 12th, at 8 0 a.m.

A TRAIN will also leave MERTHYR and ABERDARE for NEATH, in
connexion with the South Wales Train.

On the Return Journey, passengers will be forwarded up the Vale of Neath by the next succeeding
Train after the arrival of the Train from London.

TIME AND FARE TABLE.

	A.M.	FIRST CLASS	COVERED CARRGES		A.M.	FIRST CLASS	COVERED CARRGES
Haverfordwest	7. 0	33s.	23s.	Aberdare	9. 5	30s.	20s.
Narberth Road	7.30	30s.	20s.	Neath	10.18	27s.	18s.
St. Clears	7.50	30s.	20s.	Port Talbot	10.30	25s.	17s.
Carmarthen	8.15	30s.	20s.	Bridgend	10.55	24s.	16s.
Llanelly	9.15	30s.	20s.	Cardiff	11.55	22s.	15s.
Swansea	9.50	28s.	19s.	Newport	12.10	22s.	15s.
Merthyr	9. 0	30s.	20s.	Chepstow	1.15	20s.	13s.

THE
CRYSTAL PALACE AT SYDENHAM

Is now open at 1s. each, and parties therefore will have ample opportunity of visiting it by
these arrangements.

TICKETS will not be transferable, and are only available for the Return Journey by the Special
Train. One single Package of Luggage will be allowed to each Passenger ; all other articles
will be charged as parcels.

SWANSEA, JULY 19th, 1854. FREDERICK CLARKE.

2 E. PEARSE, MACHINE-PRINTER, "RAILWAY GUIDE" OFFICE, SWANSEA.

A railway advertisement for an excursion to London in 1854. The train left Neath at 10.18 a.m. and the First Class fare was 27s (£1.35), with the fare for the 'covered carriage' costing 18s (90p). It is interesting to note the route the train took, travelling from Haverfordwest before calling at Neath.

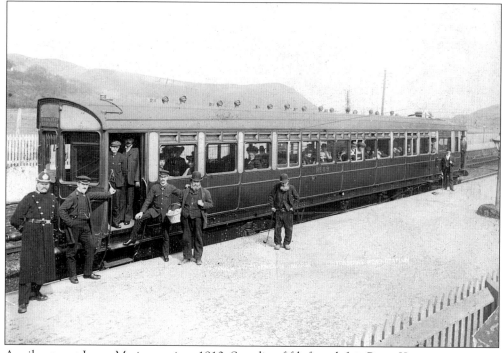

A railmotor at Jersey Marine station, 1910. Standing fifth from left is Percy King.

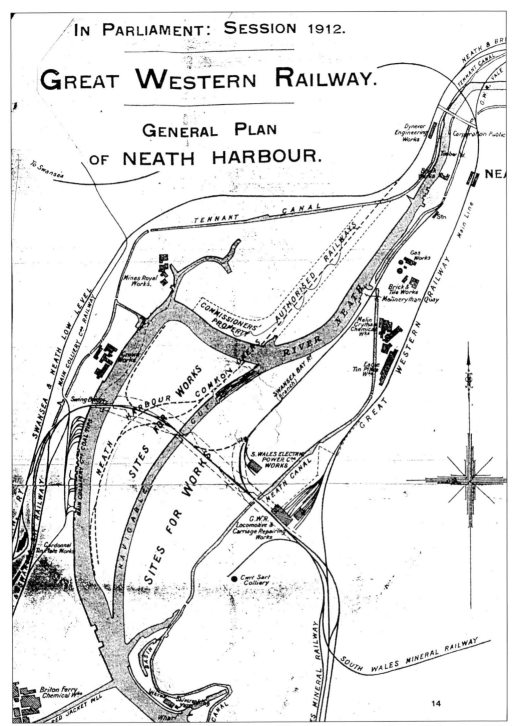

A map from the parliamentary plans for the Great Western Railway in Neath Harbour in 1912. These were the plans drawn up for debate in parliament, and would have formed the basis for a sanction for building to begin. The plan never came to fruition, however; if it had the marshland we know today from Briton Ferry to Neath Town would be under concrete and machinery.

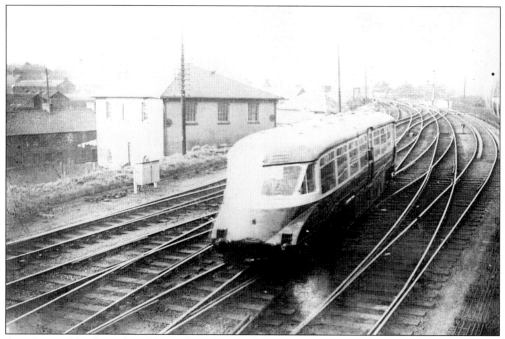

A railcar at Neath in the 1930s. The white building, centre left, is Zoar chapel, which is now used as a feedstore for animals.

Neath General Station in the 1940s.

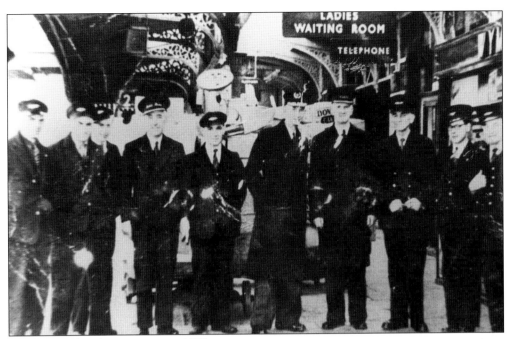

Staff at Neath railway station, *c.* 1950.

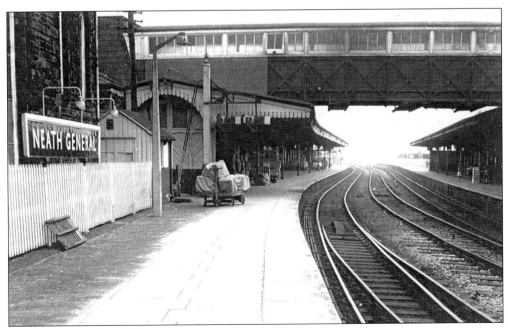

Neath station in the 1950s.

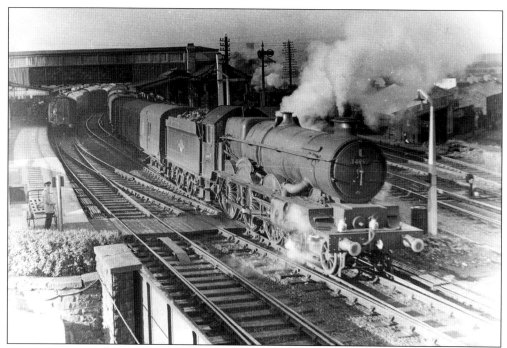

A passenger train leaving Neath destined for Swansea, 1950s. Note the postman on the left waiting to cross the line.

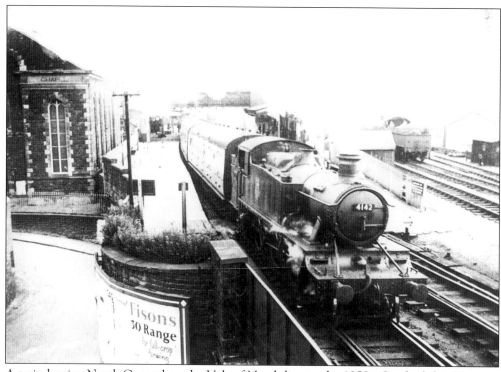

A train leaving Neath General on the Vale of Neath line in the 1950s. On the left is Maes-yr-Haf chapel.

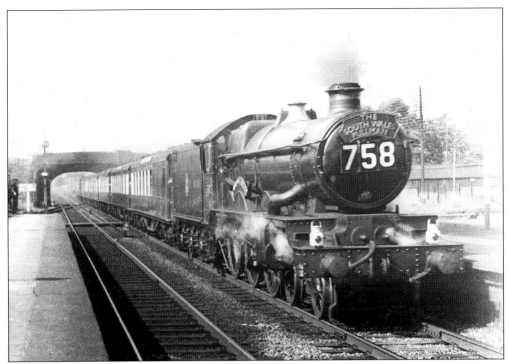

The *South Wales Pullman* at Briton Ferry station in the 1950s.

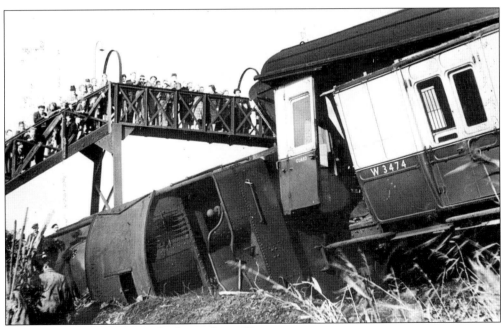

A train crash near Cwrt Sart bridge in the 1950s.

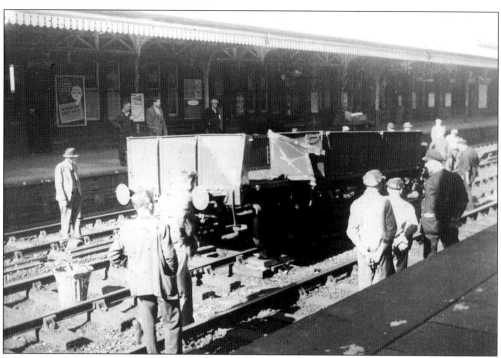

Another derailment in the 1950s. This one shows trucks askew at Neath General.

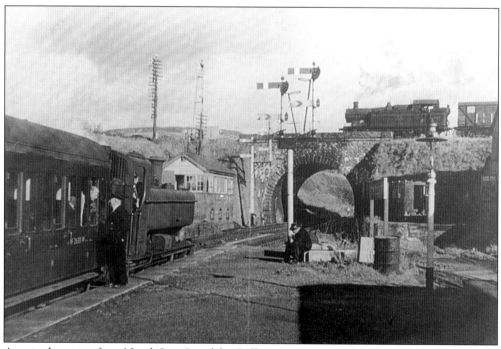

A train departing from Neath Low Level for Colbren at Riverside station in 1955. The fireman on the footplate is author, Bryan King.

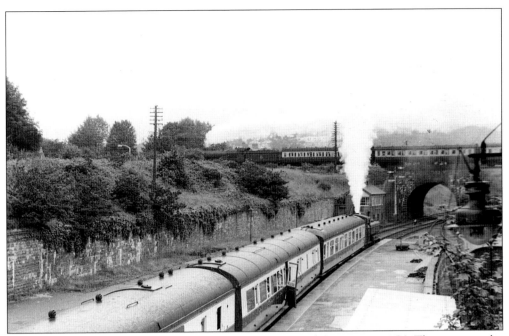

Neath Low Level (Riverside station) with a train destined for Brecon 1956. The train on the bridge is the Paddington to Swansea.

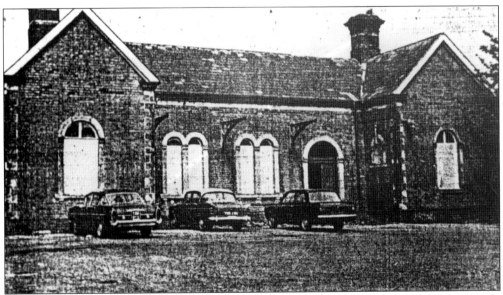

Neath Riverside station, c. 1960. This was located opposite the Education Office on Neath Abbey Road. A footbridge leading to Bridge Street now passes the site.

Norman Jones could appropriately have been called Neath's Mr Transport. A dedicated railwayman, he was based at Neath station in the 1960s. He recorded in photographs the transport of the Neath area and many of his illustrations are used in this book. Norman lived in Briton Ferry.

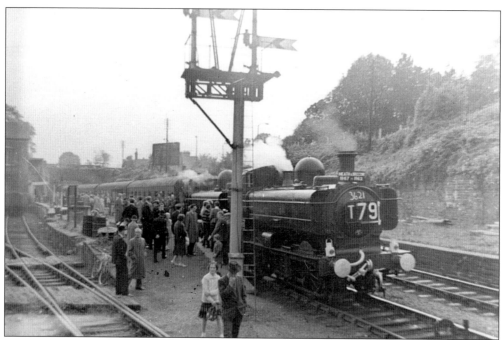

The last special passenger train to commemorate the closing of the Neath & Brecon line in 1962.

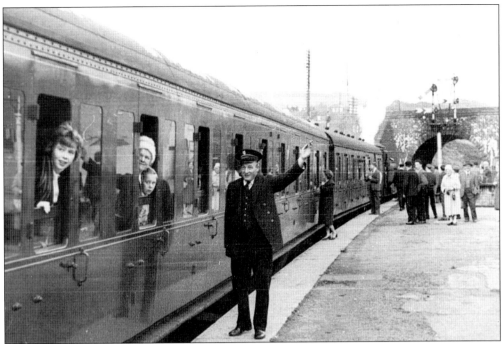

The last 'booked' train to leave the Riverside station on route to Brecon, 30 November 1962.

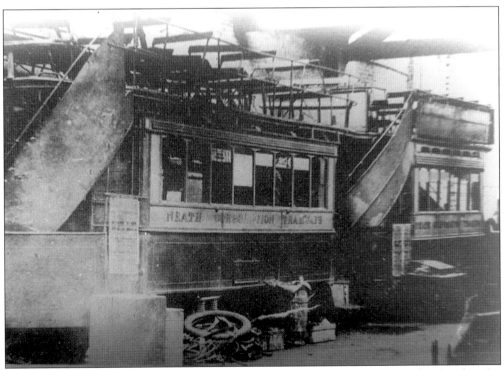

Neath Corporation Tramways tram shed, 1920. This shed was located on London Road in the garage opposite the *Neath Guardian* newspaper's office.

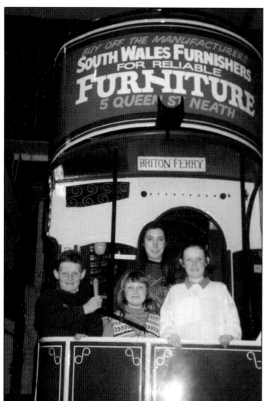

Seventy years later and an example of the tram is reconstructed to its original glory. This one was on show in the Cefn Coed Museum, Crynant, in the early 1990s. Left to right: Nicholas Williams, Rebecca Thomas, Sara Hughes, Joanne Williams. The children have an historical connection with the tram as their great, great grandfather, Jack Williams of Briton Ferry, was the tram driver and their great grandfather, Hugh Fisher Williams was the conductor.

A Creamline service bus near Tonmawr in the late 1970s.

The GWR (later Western Welsh) bus garage at Cadoxton in the 1920s. This garage was located on a site which is roughly behind Golwg y Gamlas and about two hundred yards north of Lidl's store. This shot shows a half cab at the depot.

Outside the depot.

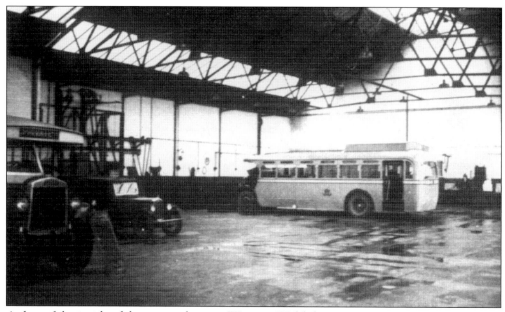

A shot of the inside of the garage showing Western Welsh buses.

A bus fitter taking a rest at the Western Welsh depot.

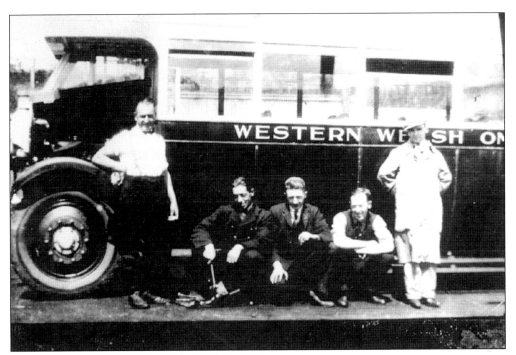

Western Welsh bus and staff at the Cadoxton garage.

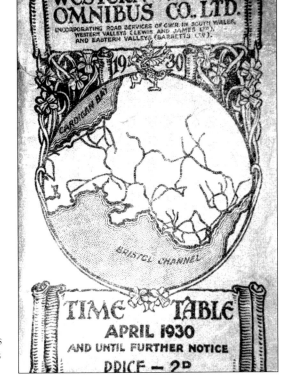

A picture of a Western Welsh timetable from April 1930. It is interesting to note the history of the company as, up to this date, it had incorporated the road services of the Great Western Railway (GWR) in South Wales, Western Valleys (Lewis & James Ltd), and Eastern Valleys (Barretts Ltd).

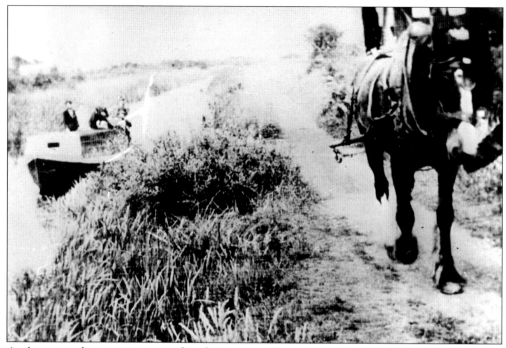

A slower, and more serene mode of transport. Home time for the children meant being conveyed by barge and horse along the towpath at Jersey Marine to Pritchard's Cottages, *c.* 1910.

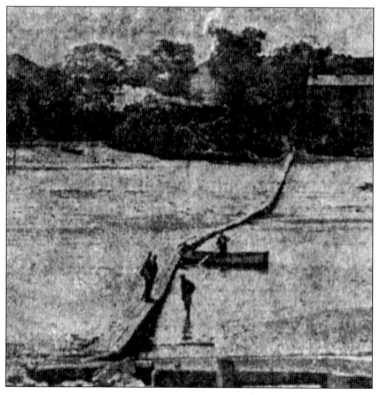

Briton Ferry Inn, in the background, with the old walkway across the river Neath, *c.* 1910. The ferryboat is waiting for the tide to come in. At this time these boats were the only means of crossing the river at Briton Ferry.

Three

Industry and Business

Cilfrew tinplate works in the 1880s. Sitting third from the right on front row is John Evans.

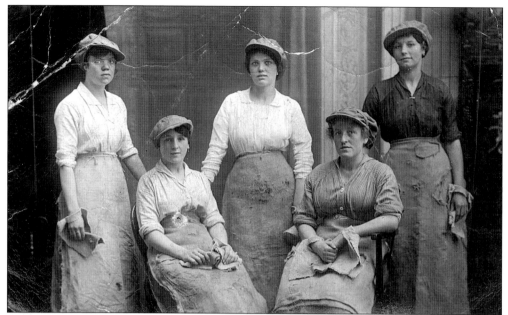

Women workers at Melin tinplate works in 1913. They are, left to right: -?-, Nellie Broome, Martha Broome, May McCormack, -?-.

Clyne tinplate works, *c*. 1930.

The old copper works office at Red Jacket, which was later turned into a dwelling house, *c.* 1910.

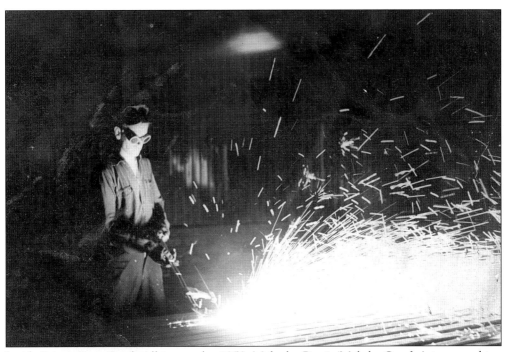

Inside Briton Ferry Steel, Albion works, 1950. Malcolm Powis 'Mal the Scarfer', is seen taking the 'flops' out of the steel. The Albion, Briton Ferry, was closed by 1977.

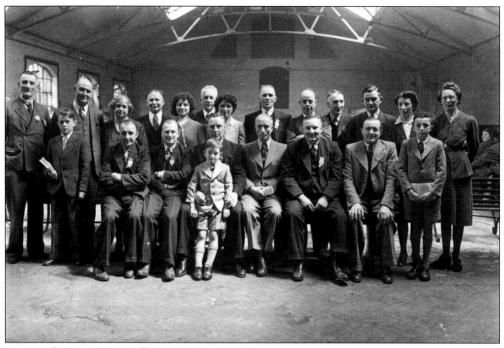

An awards ceremony at Albion works in 1970.

The cycle sheds, Albion works in 1960.

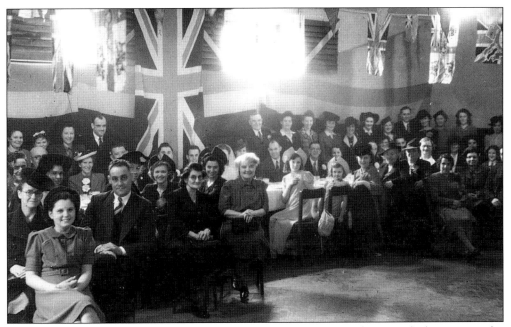

A staff function at the Galv works, *c.* 1945. This works was on the site of what is now the Milland Road Industrial Park.

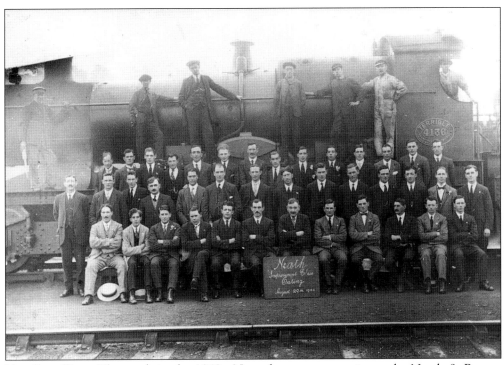

Venallt colliery, Glynneath in the 1940s. Note the passenger train on the Neath & Brecon railway in the background.

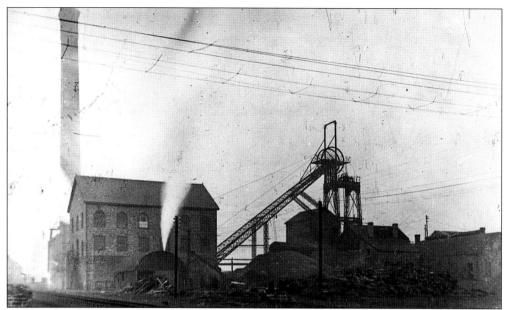

Main colliery, Dyffryn, Bryncoch, *c.* 1920.

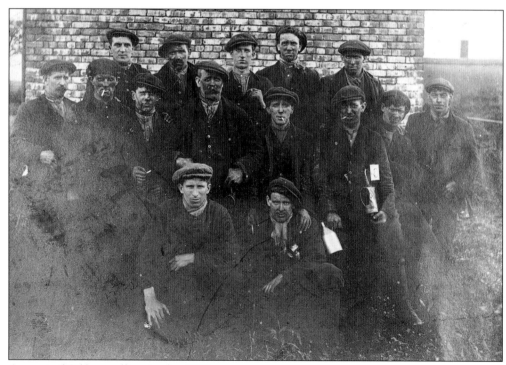

A group of Cilfrew colliers in the 1920s.

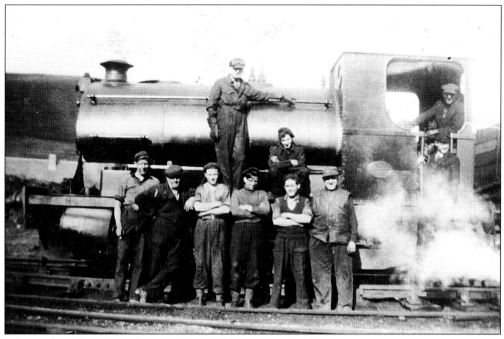

Glyncastle colliery, Resolven, *c.* 1930s. Workers pose for the camera.

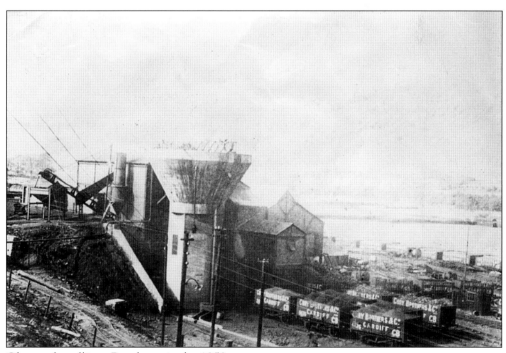

Glyncastle colliery, Resolven, in the 1950s.

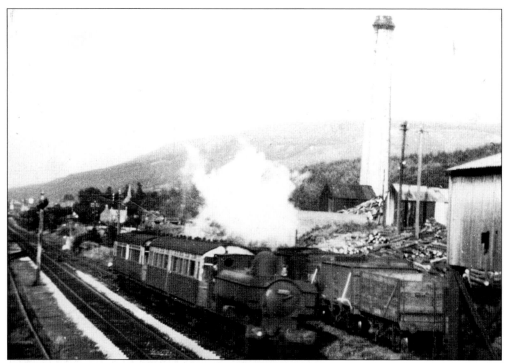

Garth Merthyr colliery, Melyn Court, on the right, *c*. 1940. Resolven can be seen in the distance as the train approaches Drehir Farm crossing.

A colliery engine crossing the River Neath at Abergarwed in 1936.

Colliery screens at
Abergarwed in the 1940s.

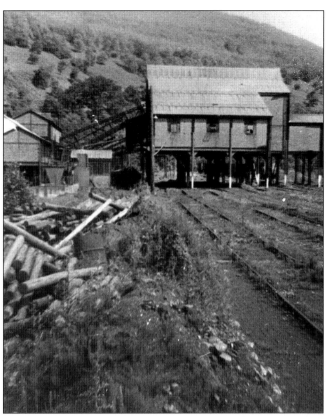

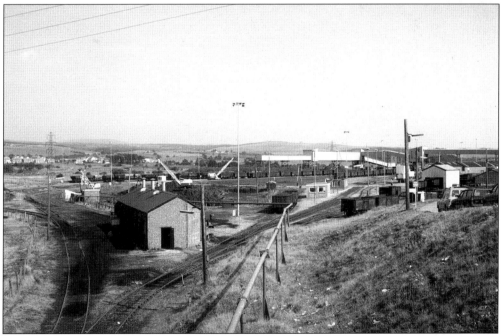

Onllwyn colliery, c. 1980. The red bricked building in the foreground was the steam engine
shed.

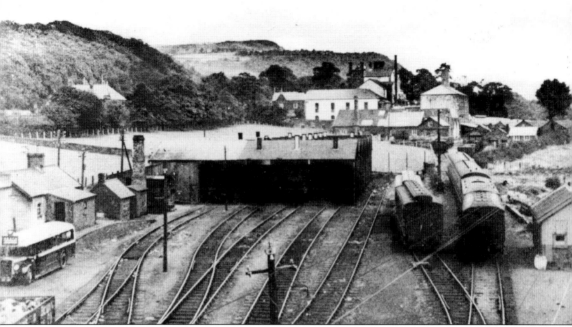

Neath & Brecon Loco sheds in the 1950s. Note the Great Western bus, left foreground, and the Vale of Neath Brewery in the background.

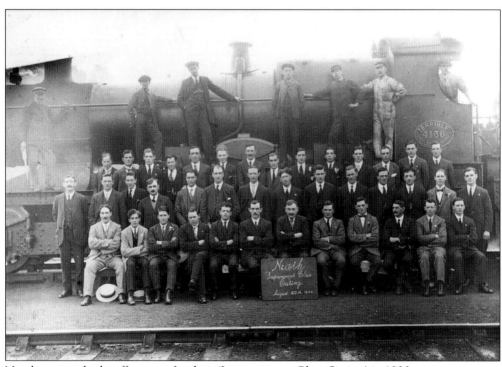

Neath engine shed staff prepare for their 'Improvement Class Outing' in 1920.

Shunters at Cwrt Sart, 1957. Left to right: G. Gibbs, H. Bishop, M. Smith.

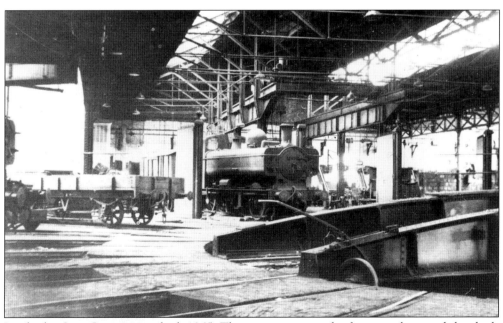

Inside the Cwrt Sart engine shed, 1965. The operation ceased a few years later and the sheds were demolished in the early 1970s.

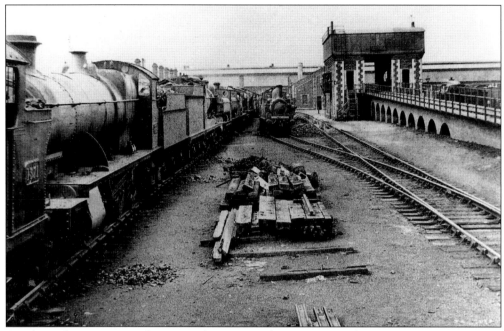

Once proud steam engines line up at the scrap yard, Cwrt Sart, in the 1940s.

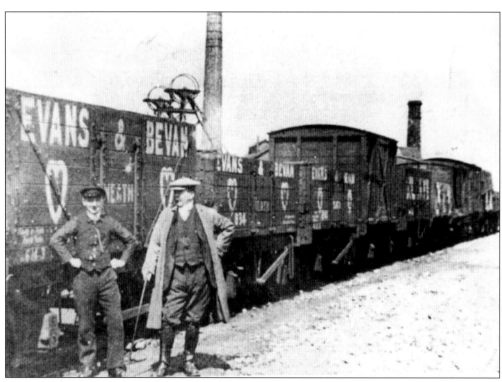

A train of wagons convey the goods of the Evans & Bevan empire at the brewery site at Cadoxton in the 1930s.

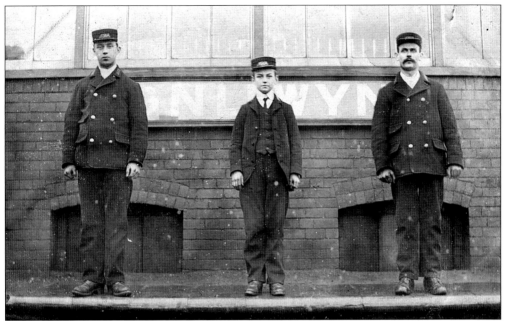

Staff at Onllwyn station in the 1930s. It was from here that coal was exported from Onllwyn colliery.

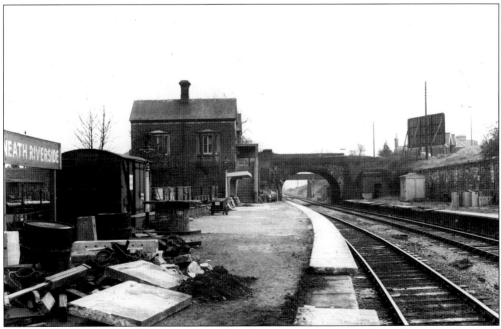

Neath Riverside station but the focus is the small box on the right hand platform in the extreme right which was called a coffin box. Apparently coffins would be conveyed from the Neath and Dulais Valley by train and placed in this box. In the building, prominent in the background, the Railway Company reserved a room for the exclusive use of Madame Patti who was a frequent user of the service from Neath to Craig-y-Nos Castle, where she would alight the train at her own halt.

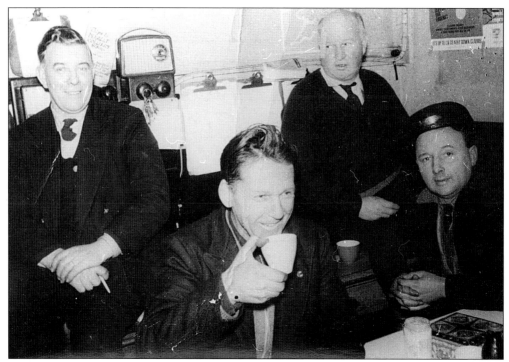

Railway staff at Glynneath station in the 1950s. The railway formed an important part of the industrial life of the area. The railway made transportation of heavy goods possible to customers all over the country.

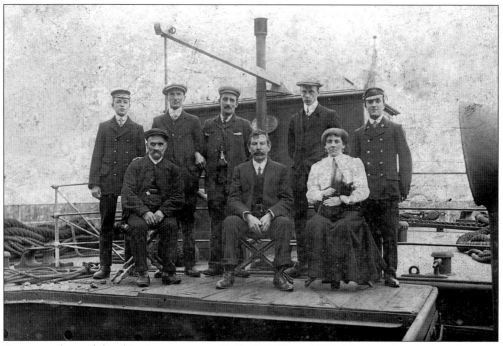

Crew members of the shipping company, Bullard & King, 1900. The location is thought to be the wharf, Neath Abbey.

The wharf seen from the first bridge at Briton Ferry, *c*. 1956.

A disused barge on the Tennant Canal at Neath in 1925.

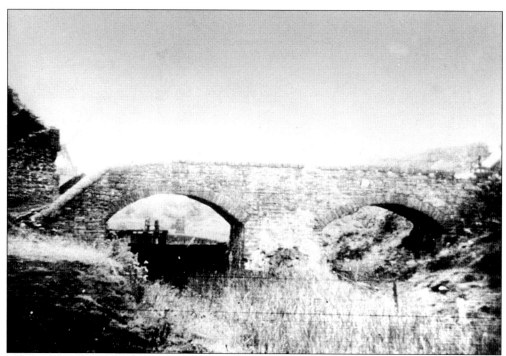

The double arch bridge which used to span the canal at Red Jacket, *c.* 1930. The river lock, where canal boats used to join the river to gain access to Briton Ferry, is visible through the arch.

Building apprentices at Treforgan, Crynant, *c.* 1950. Included in the picture are: Ivor Thomas, Dennis Williams, Eddie Davies, Bill Davies, Trevor Davies.

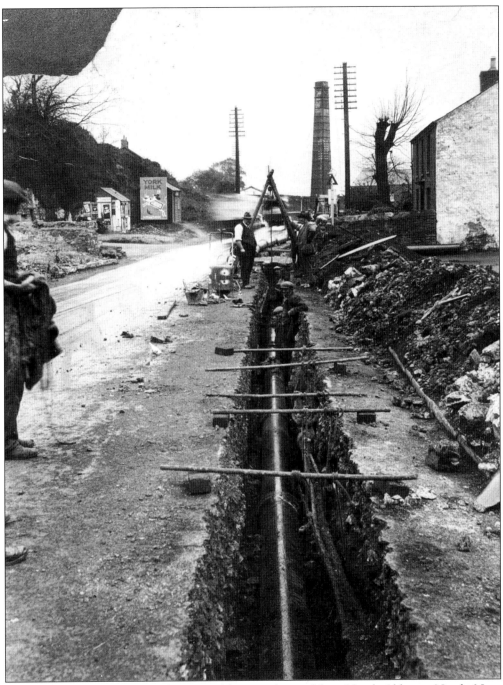

Pipe laying, Neath Abbey, in the 1940s. This was the road from Neath Abbey to Neath. Note the chimney in background.

A view looking towards Neath Abbey village and Skewen in the 1940s. On the extreme right one can make out Ty Mawr, Joseph Tregelles Price's house and the taller of the buildings in background is the Smiths' Arms public house.

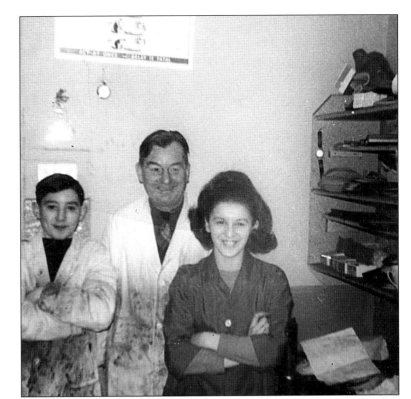

The staff of the Pagoda shoe shop, Queen Street, Neath, c. 1960. Left to right (above): Michael Morgan, Elizabeth Morris, Tom Thomas. Left to right (below): Michael Morgan, Wilf Mort, Elizabeth Morris.

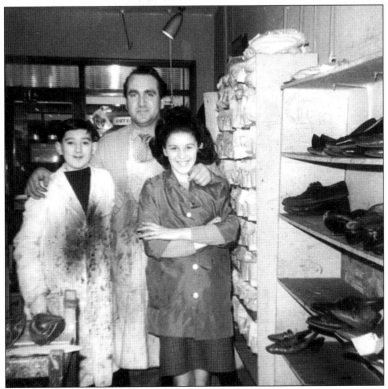

The ladies who worked at the Victoria laundry, Cadoxton, in fancy dress, *c.* 1920. They include Annie Lintern and May Derrick. The laundry business was established before 1900 and in later years it was managed by Nichols and Winfield. On the site today are the premises of a funeral director.

Four
School and Church

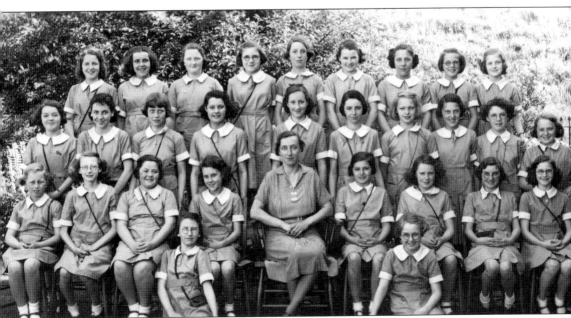

The County School for Girls, 1940. The headmistress (centre)was Miss A. Decima Jones BA.

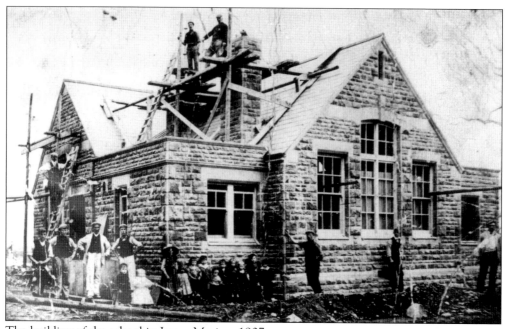

The building of the school in Jersey Marine, 1907.

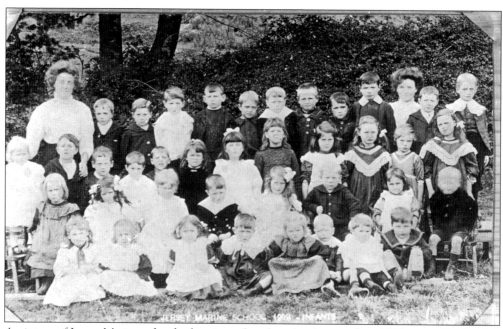

A picture of Jersey Marine school taken just after the school opened, *c.* 1908.

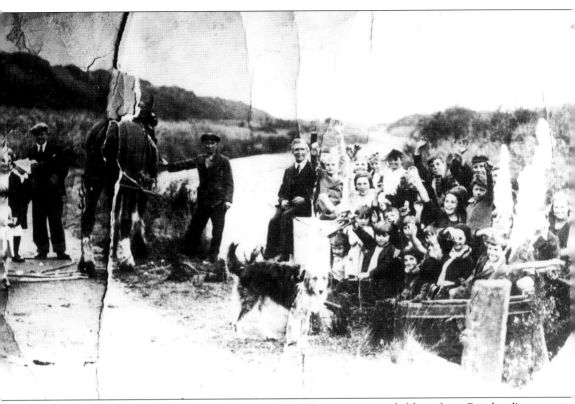

Children going to school by barge as late as 1932. Here are some children from Pritchard's Cottages stopping at Crymlyn Bridge on their way to school at Jersey Marine.

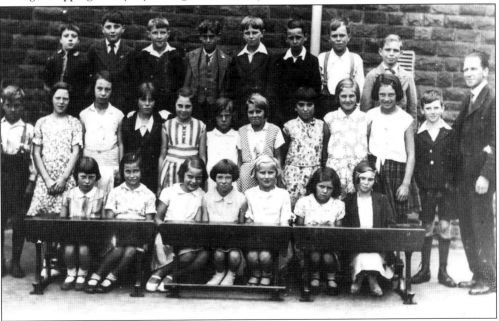

A group of Jersey Marine school children pose with their headmaster, John Davies, in the late 1950s.

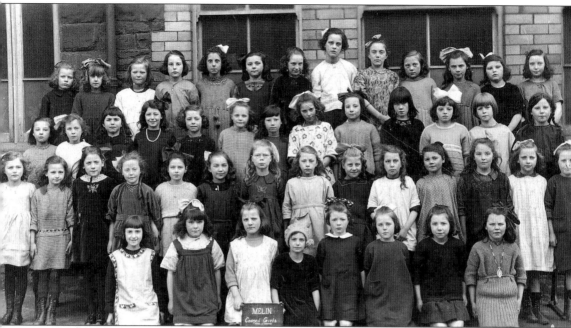

Melin council girls' school, *c.* 1920. Included are: Ruth Humphries, Maisie Thomas and Glenys Lewis.

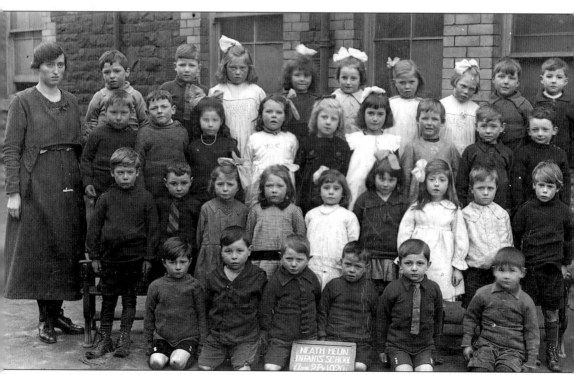

Melin infants' school, Class 2B, 1920.

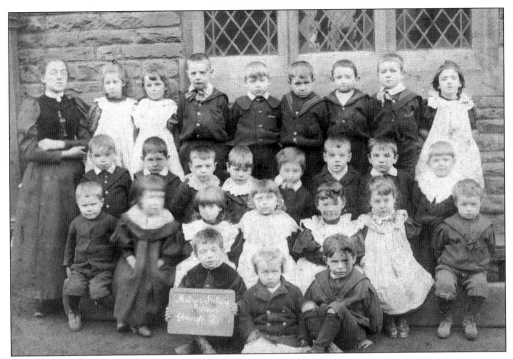

Melin infants' school, *c.* 1890.

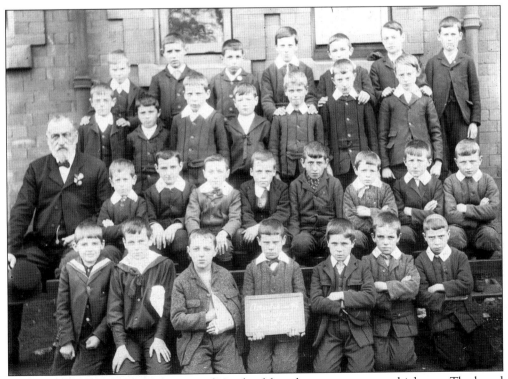

One of the schools in the Melin area of Neath, although we are not sure which one. The board held by the boy in front reads: 'Attended over 97... year ending Feb 28th 1903.'

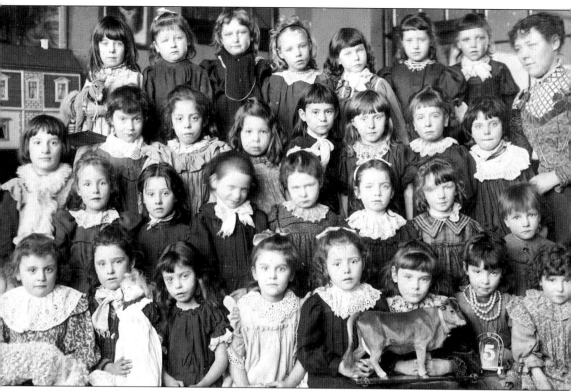

Herbert Road junior school, *c.* 1890.

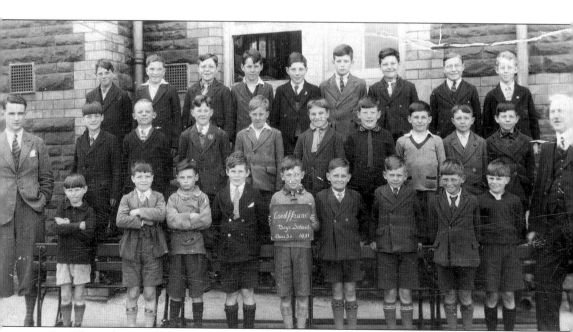

Coedffranc boys' school, Class 5a, 1931. George Gardiner is standing third left on the second row.

Boys from the Gnoll school, July 1949. Left to right, back row: Brian Collins, Leslie Rice, Gwyn Michael, Douglas Fraser, Dewi Thomas, Tom J. Davies (teacher), Donald Crocker, Tony Pearson, Brian Milford, Allan Clee. Front row: Wilfred Mort, David Jones, Sydney Tristram, Arthur Williams, Bernard Ward, Norman Reed, Malvern Harding.

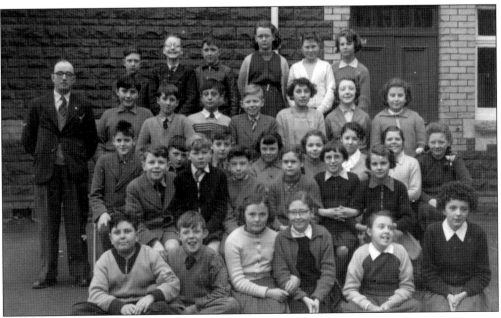

Pupils of Gnoll junior school, 1956.

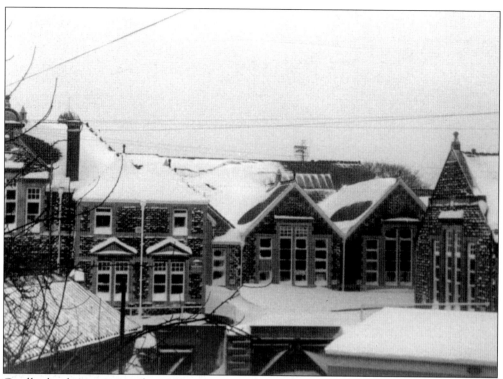

Gnoll school in winter in the 1960s.

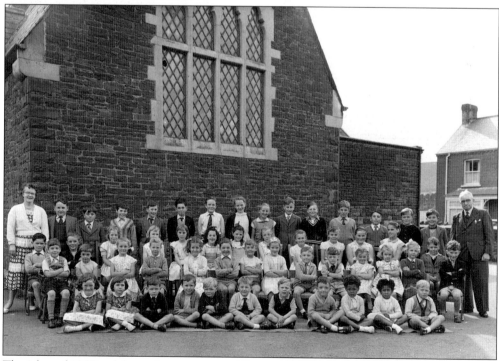

The 'class of 1957' celebrate the centenary of Bryncoch Church In Wales primary school. The teacher on the left is Mrs Tremayne and the headmaster, Mr Davies, is on right.

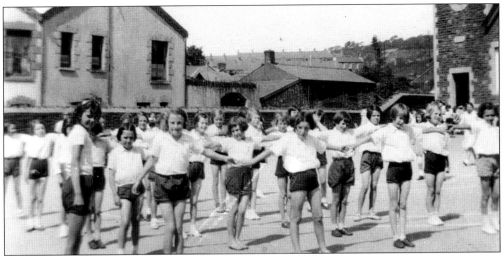

Skewen Lower girls' school in the 1940s. Included in picture are: Mary Fry, June Price, Barbara Maisey, Betty Brown, Lena Davies, Barbara Preece, Ailwyn Baker, Marjarie Oliver, Beryl Llewellyn, Jean Evans and Morveth Abel.

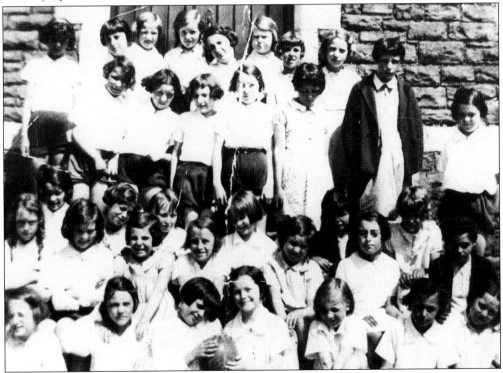

Another view of pupils at Skewen Lower girls' school in the 1940s. Left to right, back row: Elsa Stephens, Mary Rowe, Lilian Morris, Morveth Abel, Athly Davies, Jean Evans, Joyce Oakly, ? Widlake. Second row from the back: Marigold Bailey, Mair Jones, Betty Brown, Betty Jones, Margaret Sharcross, Rosela Beck, Barbara Preece. Third row, staggered: Audrey Smith, -?-, Barbara Gravell, Peggy Jeffreys, -?-, Peggy Sims, -?-, -?-, Mair Rees, Betty Thomas, Phylis Hughes, Kathleen Todd, Leona Saunders. Front row: Vera Griffiths, Betty Dunnet, Lena Davies, Beryl Llewellyn, Ailwyn Baker, Marjare Oliver, June Price.

Skewen Lower girls' school in 1949. Included are: Myra John, Janice John, Sonia Picton, Gillian Perry, Joan Fulford.

Skewen Lower girls' school, 1949. Left to right, back row: -?-, Rita Knight, Elaine Gaskins, Mary Buckley, Renvia Luke, -?- (obscured), Elaine Davies. Middle row: Doreen Jones, Valerie Williams, Pamela Smith, Myra John, Pat Jefferies, Jean Grennow. Front row: -?-, Marlene Macann, Jean Jarret, Mair Davies.

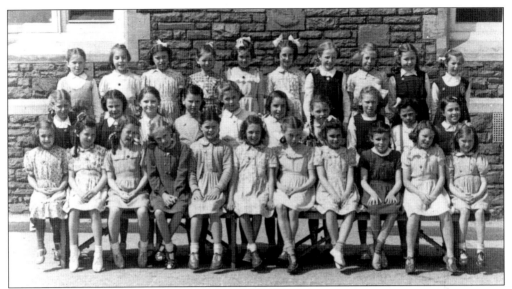

Girls from Skewen Lower school, 1948. Left to right, back row: Marlene Davies, Bey Davies, Rita Knight, -?- Doreen Jones, Mair Davies, Gaynor Smith, -?-, Leah Kriesher, Jean Smith. Middle row: -?-, Beddug Evans, Gillian Perry, Grace Fields, -?-, Marlene Davies, -?-, Gloria Kare, Avril Lewis, Clara Ferber. Front row: Yvonne Saunders, -?-, Jean Greenow, -?-, Mair Thomas, -?-, Heather Griffiths, Eirwen Jenkins, Elaine Gaskins, Janice Johns, Marlene Hopkins.

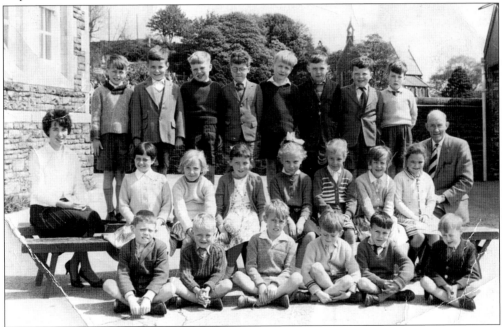

Skewen Lower (Mynachlog Nedd), c. 1962. Left to right, back row: Steven Hughes, Terry Davies, Hugh Ballad, Alan ?, Ralph Reeves, Harry Saunders, Haydn Parry, -?-. Middle row: Miss Elizabeth ?, Susan Burgess, Gillian Oakley, Susan Roberts, Ann Williams, Pauline Lloyd, Rosemary Reeves, Julie Elias, Mr Griffiths (headmaster). Front row: -?-, Christopher Britton, David Rawlings, -?-, Philip Richards, Martin King.

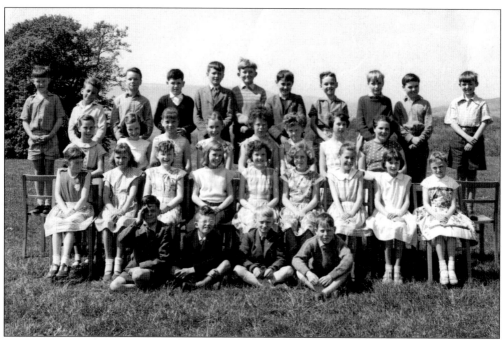

Children at Crynallt school, Cimla, in 1966.

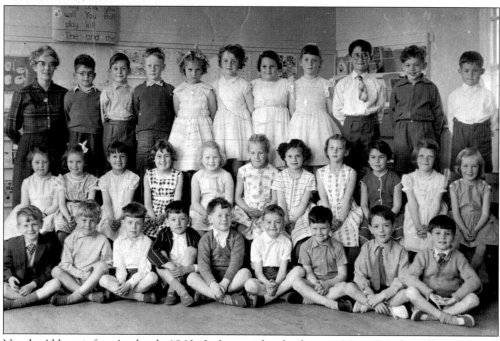

Neath Abbey infants' school, 1960. Left to right, back row: Miss Gough, Allan ?, David Griffiths, Phillip Weeks, Ann Williams, Julie Davies, Elaine ?, Susan Roberts, Keith ?, Harry Saunders, -?-. Middle row: Lyn Davies, Susan Willing, Carol Cox, Linda Bendle, Elaine David, Pauline Lloyd, Gwyneth ?, Ann Saint, Carol Williams, Denise Mellin, Marie Nichols. Front row: Steven Hughes, David Rawlings, -?-, Keri Noot, -?-, Vaughan Penny, Gary ?, John Rewbridge, Robert Chapman.

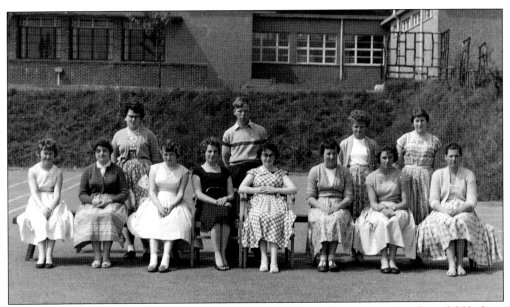

The pre-nursing course at Rhydhir school in 1958. The teachers sitting fourth and fifth from left in the front row are Nano Harris and Elizabeth George.

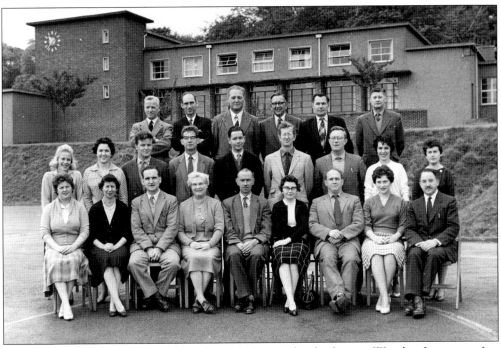

Staff of Rhydhir secondary modern, 1959. Left to right, back row: Wyndyn Lawrence, Les Watts, Granville Davies, Idwel Owen, Harry Morris, Phil Roberts. Middle row: Gill Gambold, Jill Handford, Dillwyn Thomas, Reg Teale, Tom Lewis, Gwyn Davies, Swithin McNeil, Elizabeth Morgan, Mair Davies. Front row: Ann Williams, Margaret Stone, M.L. Davies, A. Tchavdarova, Clive Trott (headmaster), A. Jones, Tudor Rees, Cynthia Donald, Jack Llewellyn.

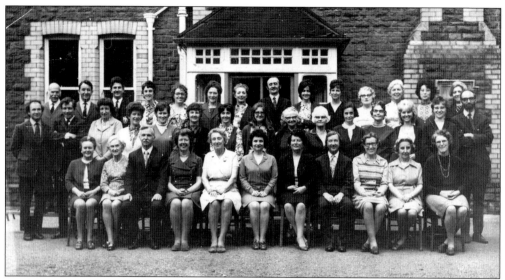

Staff of Neath girls' grammar school, 1973. Left to right, back row: -?-, Dennis Jones, Gareth Morgan, Stella Matthews, -?-, Vi Price, Cynthia Betts, Mair Williams, Doug Evans, Miss Whitehouse, -?-, Madam Winnie Richards, Pat Bryant, Glenys Oatway. Middle row: Brian Winstone, Noel Evans, Iris Rosser-Davies, M. Jones, Lynn Thomas, Ursula Williams, Menna Morris, -?-, Mrs Cape, Drusilla Thomas, Valmai Williams, Gwenda Jenkins, Marilyn Davies, Sheila Jones, Gren Edwards. Front row: Barbara Clayton, -?-, Jim Trusslo, Keith Wishart, Dora Roberts, Mai Edwards, Mariane Davies, Ken Owen, Betty Hughes, Eileen Simms, Margaret Austin. This was the year that the Comprehensive Education system was introduced which saw the end of grammar and secondary modern schools.

St David's Day celebrations at Neath Abbey infants' school, 1969. Left to right, back row: -?-, Alex Dymond, David Llewellyn, Robert Mort, Paul Mead, Philip Williams, -?-, Rees Evans, Paul Davies, -?-. Middle row: Cheryl ? , Tracy Hancock, Tracy Williams, -?-, Delfryn Jenkins, Ann Fergason, -?-, Mary Pologeno, Susan Jackson, -?-. Kneeling in front: -?-, Maureen Howells.

Longford Memorial Hall nursery group, 1976. Included are: Aunty Daphne (Maillon), Jonathan Garthwaite, Richard Doran, Kerry Michael, Margaret King and Aunty Sandra (Michael).

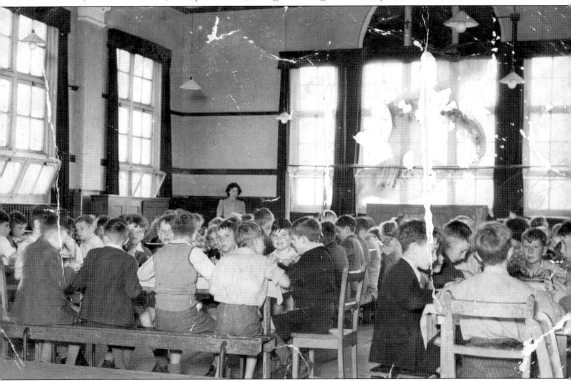

Children at 'dinner time' at Cadoxton junior school, *c.* 1948. Included in the scene are: Cellen Jones, David Ovard, Lynn Jefferies, Terry Evans, Alwyn Harries, David Lewis. There is some debate who the teacher is but the consensus comes down on the side of Miss Gertie Bowen. This school once occupied the site now used by Cadoxton Comprehensive.

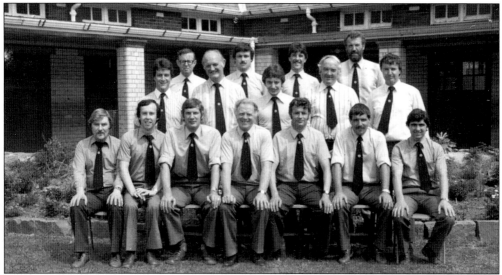

Old block staff at Llangatwg comprehensive school, Cadoxton, 1985. Left to right, back row (staggered): H. Davies, B.C. Davies, D. Thomas, R. Scilton, C. Terry, R. Owen, G. Jones, D. Evans, G. Jones. Seated in the front row: J. Lloyd, A. Williams, G. Herdman, H. Jones, M. Jones, G. Predie, J. Davies.

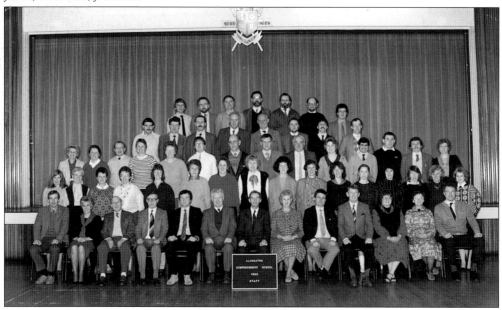

Staff of Llangatwg comprehensive school, Cadoxton, 1988. Left to right, back row: B. Davies, K. Martin, G. Jones, C. Morris, D. Richardson, B. Morgan, H. Davies. Second row from the back: G. Predie, M. Hughes, S. Hughes, R. Powell, D. Thomas, C. Manley, R. Owen, A. Williams. Third row: H. Davies, C. Davies, A. Davies, I. Hill, R. Windfield, P. Jones, N. Morgan, C. Parish, G. Jones, C. Heale, J. Davies, C. Fuge, C. Terry, P. Lewis. Fourth row: P. Evans, Menia Morris, P. Widlake, M. Williams, -?-, W. Gronow, A. Carter, N. Jones, Rose Evans, M. Phelps, M. Lewis, S. More, M. Ellis, J. Foulks, V. Piece, K. Thomas. Front row: G. Herdman, J. Pitts, M. Williams, B.L. Davies, A. Williams, R. Preece, David Williams (headmaster), M. Minchinton, R. Scilton, V. Hill, A. Morgan, M. Thomas, D. Evans.

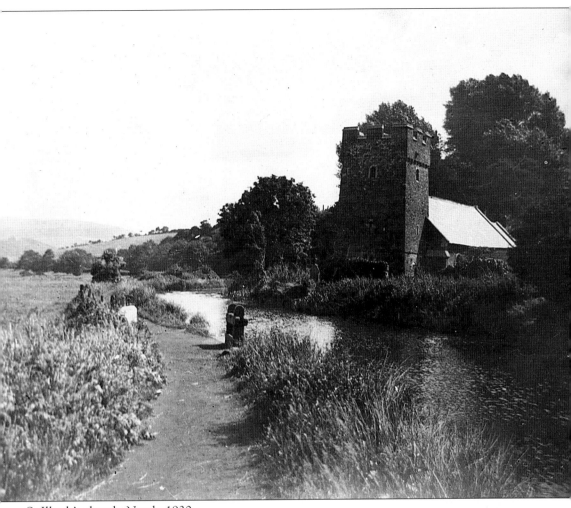

St Illtydt's church, Neath, 1930.

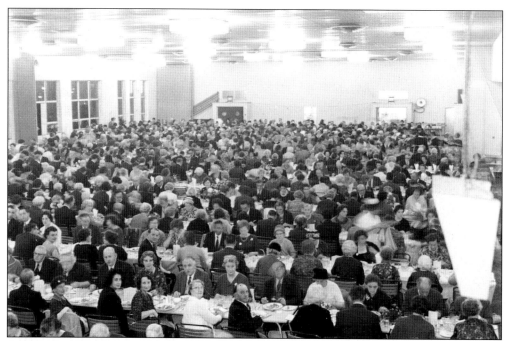

A Church in Wales stewardship meal held in the Metal Box canteen, *c*. 1950.

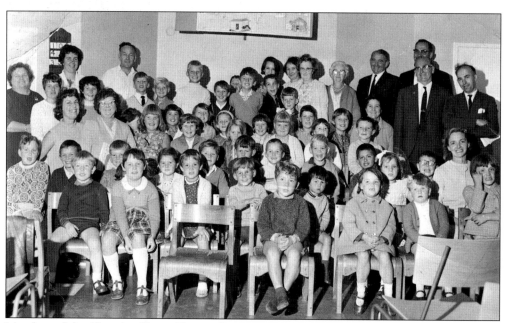

Members of the Church of Jesus Christ of Latter Day Saints, Skewen Mission, in the 1960s.

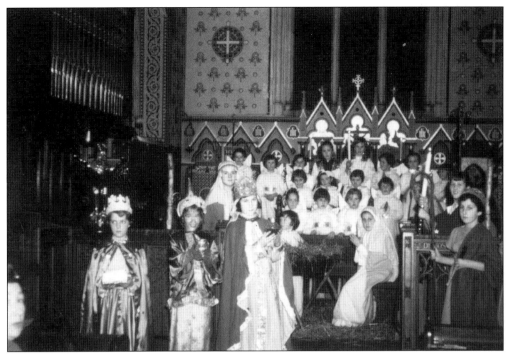

The Nativity Play at St Matthew's church, Dyffryn, Bryncoch, Christmas 1961.

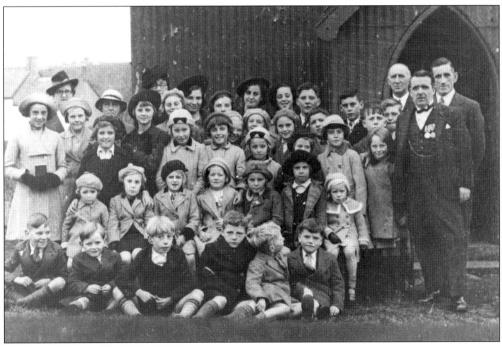

The Sunday school at Jersey Marine, 1938.

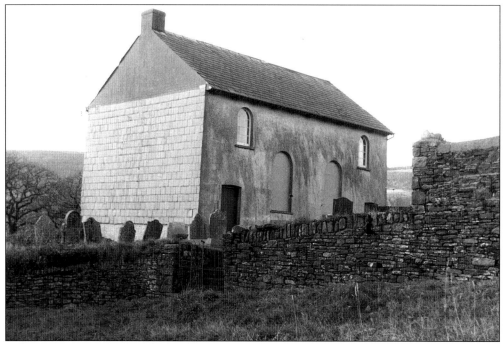

Capel Melyn Court in 1985. The chapel celebrated its 200th anniversary in 1999. The hymnologist, Hopkin Evans who died in 1940, is buried in the churchyard.

St Matthew's church choir, Dyffryn, preparing for an outing in the 1940s. Included are: Bill Adams (choirmaster), Alan Phillips, Martin Richards, Malcolm Lewis, Malcolm Powis, Harry Hire (organist), Ieaun Jones, Martin Evans, Eric Bradley.

Five
Sport and Recreation

Onllwyn football team, 1949. Left to right, back row: Will Stephens, Gwyn Roberts, -?-, John Stephens, Len Davies, Alwyn Lewis, -?-, -?-, Ray Howells, -?-. Front row: Benny Williams, Bernard Payne, Viv Howells, -?-, -?-, Talwyn Williams, -?-.

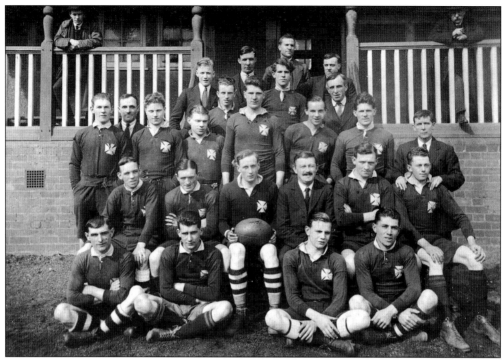

A Neath rugby team in the 1920s. Included are George Smith from Penydre and Pep Melin.

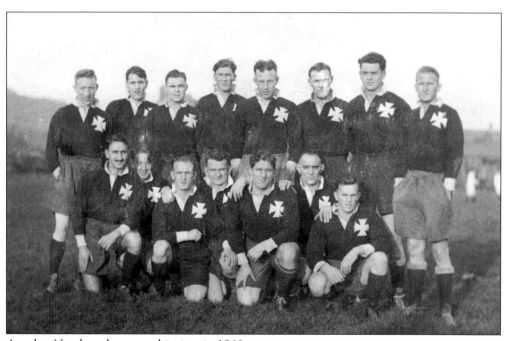

Another Neath rugby team, this time in 1946.

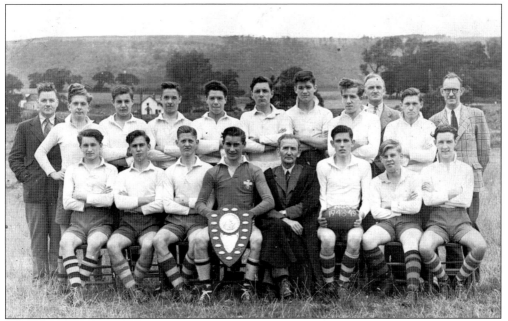

Neath boys' grammar school rugby team, 1948.

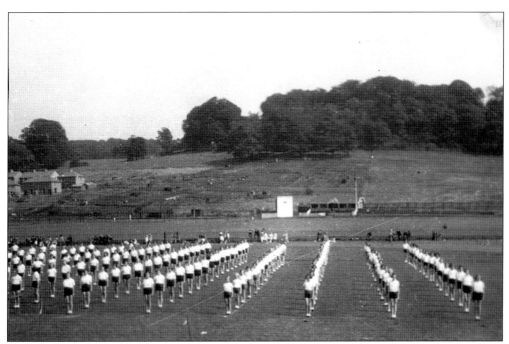

Neath schools' PT display at the Gnoll rugby ground, 1936. The schools that are represented in the picture are Alderman Davies', Brynhyfryd, Cwrt Sart.

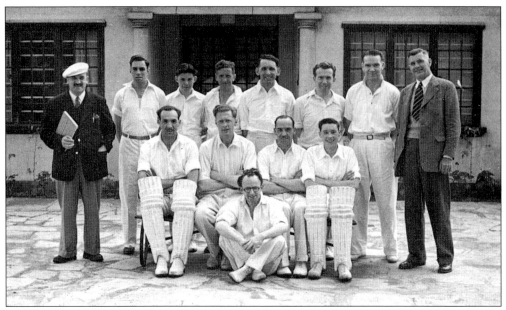

Metal Box cricket team in the 1950s.

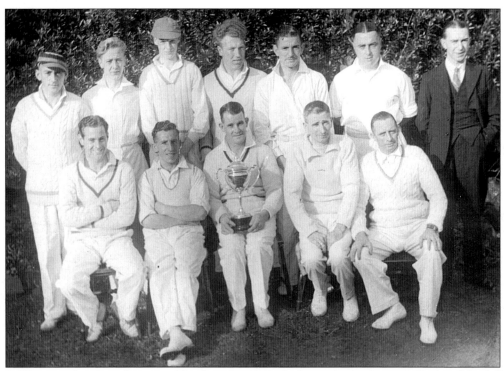

St Thomas' church cricket team, Neath in the 1950s. Left to right, back row: Billy Arnold, Cliff Bartlett, -?-, Ivor David, Morton Smith, Ernie Molland, George Hunkin. Front row: -?-, Billy Webb, -?-, -?-, George Thomas.

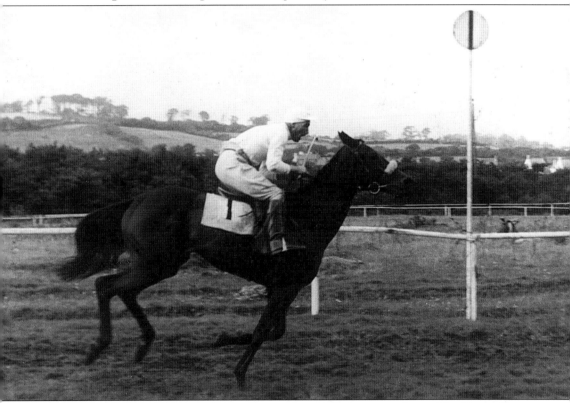

CADOXTON CRICKET CLUB
ATHLETIC SPORTS.

EASTER-MONDAY,
1885.

ONE SHILLING.

A ticket admitting one for a shilling to an athletic sports day at Cadoxton Cricket Club in 1885.

Air Queen winning at Tondu, with Resolven jockey, Bill Carey, in the saddle. Trained in Resolven by Vernon Place and owned by Arthur 'Bobby' Davies, Air Queen won 100 races during the late 1940s and the mid '50s, a feat which, by any standard is phenomenal.

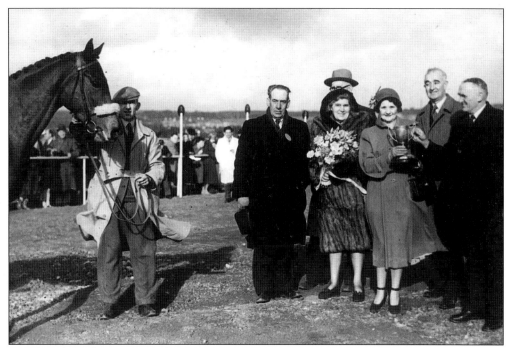

Another shot of Air Queen after a win at Swansea in 1953. On the left, holding the horse, is Vernon Place, followed by Mr McGilvery (racecourse owner). On the right is Mrs McGilvery, presenting the cup to Arthur 'Bobby' Davies.

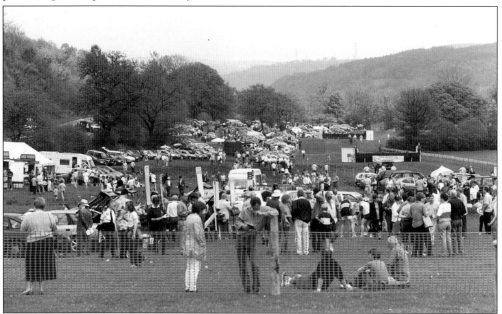

Horseracing at Pentreclwydau on May Day 1999. This popular racecourse in the Vale of Neath is once again 'calling home the horses' after a gap of nearly 50 years. There are many people who have been involved in the resurrection of this historic racecourse but Dai Pugh and Billy Hancock deserve special note as the architects of the project. On May Day 1999 more than 4,000 attended the races.

A whippet racing programme from 1927. Imagine the grooming and training that these working men would have employed to prepare these dogs to compete for a prize of £1,000.

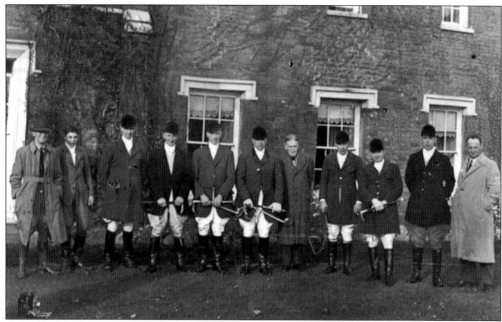

Hounds gather at Cwrt Herbert, the home of the Price family in 1947. Left to right: Representative of the Ministry of Agriculture, Martin Price, Dilwyn Thomas, -?-, William Thomas, David Price, Dr Armstrong of Crynant, Clifford Price, Ivor Griffiths, Idwal Price, Gwyn Maybery.

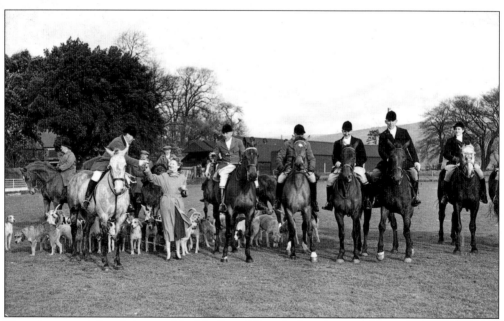

The stirrup cup is handed around by Mrs David Price before the meet leaves.

BP Llandarcy Angling Club's annual dinner, 1966. Included are: Robert Woods, Stephen Absalom, Howard Evans, Bill Absalom, Geofrey Evans, Stan Hill, Grif Evans, Louise Robson, Eric Woods, Pat Williams, Betty Williams, Ernie Burgess, Dudley Florence.

Neath Bird in Hand North Road Pigeon Club, 1964. Included are: George Sokaliski, Jacky David Morgan, Reg Peters, Sid Veale, Howard Demery, John Oliver Davies, Brian Powis, Jim Isaac, Ben Jefford, Glyn Pritchard, Eddie 'Dogger' Matthews, George Harris, Philip Jones, Eiron Thomas, MrCoop, Dick Morgan, Wilf Mort, Will Carpenter, John Coleman, Phil Fishlock, Mr Morgan, David Ovard.

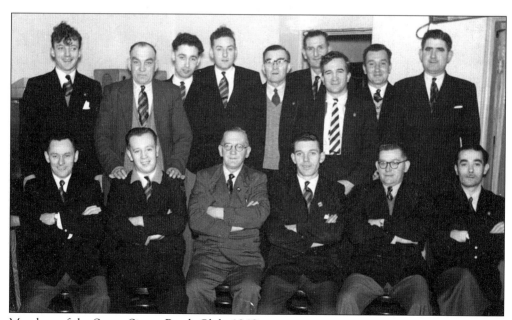

Members of the Seven Sisters Bowls Club, 1948.

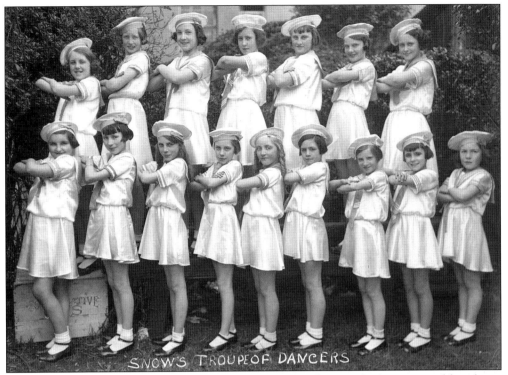

Snow's troupe of dancers in 1940. Miss Flossie Snow lived at Cimla Crescent and her dance troupe was held in great esteem. Left to right, back row: Jean Walker, Marjorie Richards, Barbara Williams, Beryl Joseph, Joan Powell, Sheila Godwin, Marjorie Thomas. Front row: Pat Williams, Glenys Thomas, Phyllis Bryce, Marjorie ?, Vena Barnes, Marion Harris, Dorothy Tinknell, Marion Davies, Barbara Leigh.

Members of the Vale of Neath Railway Society at their depot in Aberdulais in 1988. Left to right: Dave Llwellyn, Bryan King, Kester Reason, Stephen Clifford.

Storage of locos at Abergarwed, around 1990, when the Vale of Neath Railway Society moved to the village. Pictured on extreme left is Fred Leycock of Abergarwed Farm.

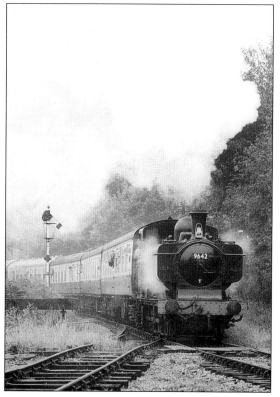

Loco 9642 GWR tank engine heading a passenger train between Lydney and Norchard (Shades of the Vale of Neath) in the early 1990s. This type of steam-powered passenger service, available in the Vale of Neath and the Dulais Valley for tourists ands locals alike, was the dream of the now defunct Vale of Neath Railway Society. Author Bryan King is a shareholder in this engine, owned in the most part by the South Wales Pannier Group, and it is currently on loan to the Dean Forest Railway. It was first restored in BP Baglan Bay but was moved to the Upper Bank Works of the Swansea Vale Railway to complete the work. The engine was the last GWR loco to be built in Swindon in 1946.

Six

Entertainment
and Events

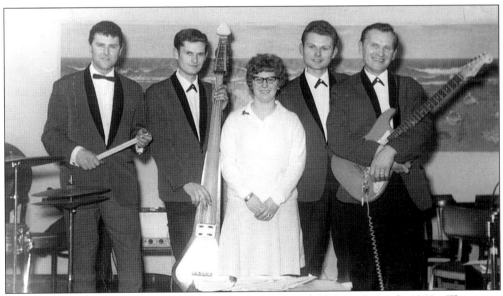

Vern Davies (right) and his band at the Glynneath Social Club in the early 1960s. They were active in the South Wales area in the 1960s and commanded a large following. Vern, from Abergarwed, was justly proud of the quality of their music and the way they presented themselves on stage. His twin sons, Mike and Pat, were band members and the vocalist was Maureen, who was married to Mike. A family affair, they called themselves 'The Small Band with a Big Reputation' and after thirty years many people in the area still remember them. They are, left to right: Doug Gooding (drums), Pat Davies (Bass), Maureen Davies (vocals), Mike Davies (organ), Vern Davies (guitar).

The Vern Davies Band playing at the 'Tramps' Dance' in the Palm Court, Castle Hotel, Neath, in the early 1960s. They are, left to right: Doug Gooding, Pat Davies, Vern Davies, Mike Davies.

St David's Church Guild in a play produced by Mrs Stanley Thomas, 1947. Included are: David Walters, Cynthia Vaughan, Annette Pike, Dorothy Walker, Susan Salter, Shirley Dunn, Donald Thomas, Norma Love, Jean Russell, Kathleen Hutchins, Ryland Tippit, Sheila Rouse, Maria Hughes, Susan Jenkins, Jane Illingworth, Margaret Colwell, Roddy Walters, Peter Venables, John Williams, Carol Tate, Mrs Roberts, Heather Trick, Gaynor Thomas, Shirley Owen, Clive Latty, Pat Wathan, Mrs Walters, Mrs Richards, Mrs Smith, Mrs Roberts, Monica Lammas.

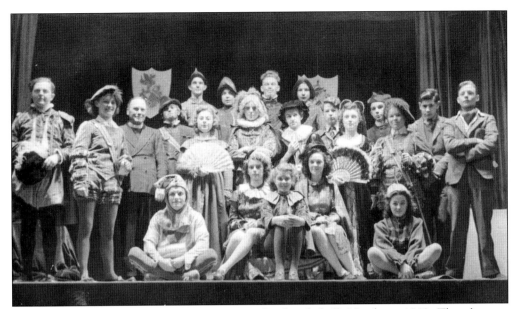

The cast of *Twelfth Night* on stage at St David's church hall, Neath, *c.* 1940. The play was produced by Revd Hopkins. Included are: Rector T.A. Roberts, Dudley Hopkins, Graham Hopkins, David Hancock, Walter Ryan, Peter Hughes, Barbara Griffiths, June Thomas, John Phillips, Shiela Rouse, Margaret Morgan, Jill Morris.

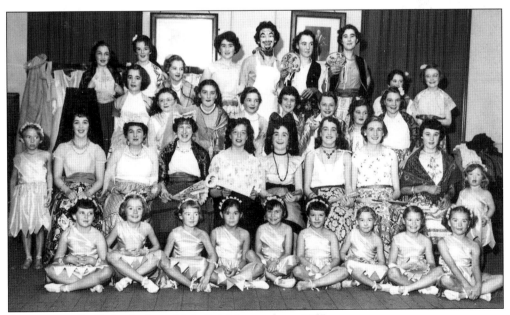

A pageant at St Catherine's parish hall, Melyncrythan, 1957.

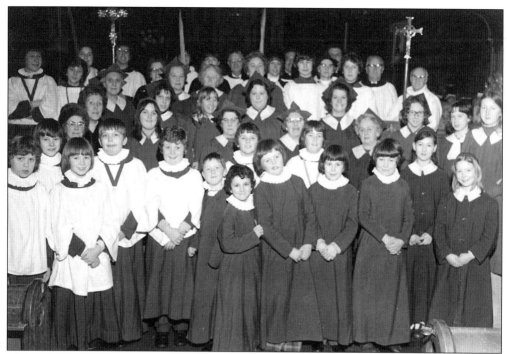

Choirs from St Thomas', St David's, St Catherine's, St Peter's and St Paul's churches all took part in the parish pageant *A King for all Seasons* at St David's church in November 1973 and January 1974. Included are: Arthur Salter, Jill Thomas, Edna Salter, Sally Samuel, Lynne Richards, Margaret Morgan, Christine Brown, Mrs Trenberth, Mrs Richards, Marie Griffiths, Renee Davies, Julie Pearn, Terry Copp.

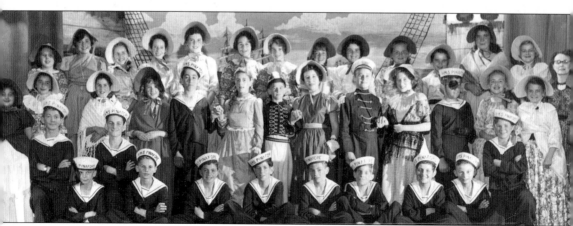

Pupils of Ynysfach secondary modern school, Resolven, perform *HMS Pinafore* in 1957.

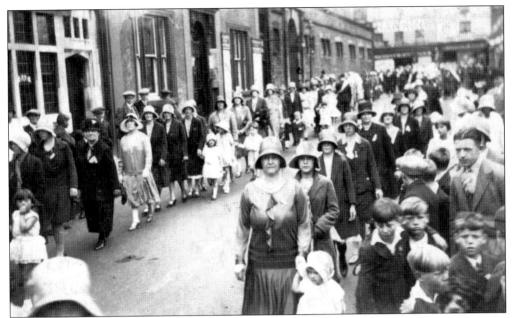

A Corpus Christi procession passes the market in Green Street, Neath, *c.* 1930.

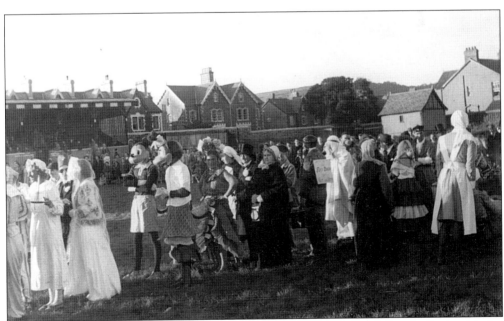

A parade from Penydre to the Gnoll rugby ground in 1945. Mary Randall is the 'Lady with the Lamp' who won first prize; but what was the occasion?

MARIA STREET CHURCH——NEATH

SUNDAY, DECEMBER 10th, 1950
at 7.45 p.m.

Grand
CONCERT

BY

THE MELYN ORPHEUS
MALE VOICE SOCIETY

Conductor - - Mr. D. J. DAVIES
Accompanist - - Mr. E. CLEMENT

With the following Artistes:

Miss VALERIE MOGFORD •- Soprano
Miss ALETHIA WALTERS Mezzo-Soprano
Mr. D. J. GRIFFITHS - - - Tenor

ADMISSION BY PROGRAMME - 1/6

PROCEEDS IN AID OF CHURCH FUNDS

A programme announcing a Grand Concert by The Melyn Orpheus Male Voice Choir to be held at Maria Street church on 10 December 1950. Admission was 1s 6d.

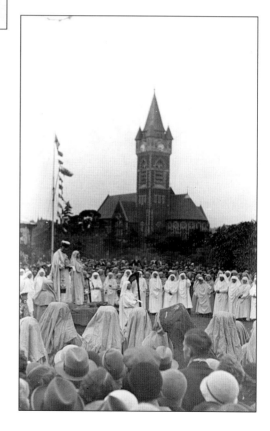

The 1934 National Eisteddfod of Wales Proclamation Ceremony held in Victoria Gardens.

Mr Walter Price and his wife, Mrs Evelyn Price, founders of Walter Price & Sons Ltd of Longford Farm, Neath Abbey prepare to leave the farm for the 1949 Royal Welsh Show.

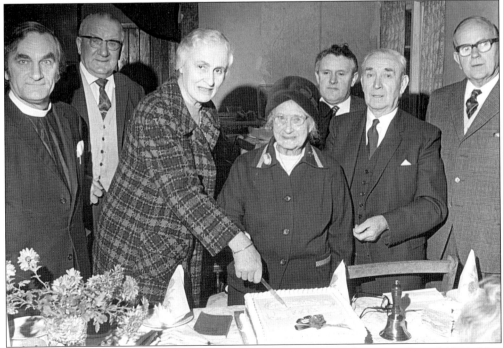

Charity Prosser celebrating her 100th birthday at Bryncoch in the November of 1974. Miss Gibbins of Glynfelin, Longford helps with the cutting of the cake and on the left is the Vicar Rees, St Matthew's church, Dyffryn.

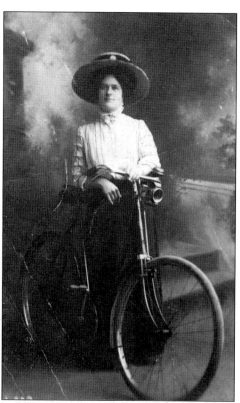

A personal event of magnitude for Rose Munckton of Neath who cycled to London and back to visit her aunt in 1900.

Longford residents outside their hotel in Blackpool in the 1950s. Most of the people seen here are from from Rhydhir and they include: Larry Watkins, Robert Jenkins, John Jenkins, Jeffery Thomas, Raymond Thomas, Billy Thomas, Janice Rees, Mrs Foster, Glenys Rees, Barbara Foster, Mrs Jones, Mrs Rawlings, Viv Davies, Esther Thomas, Freddie Jones, Millie Thomas, Mr and Mrs Fletcher, Norman Davies.

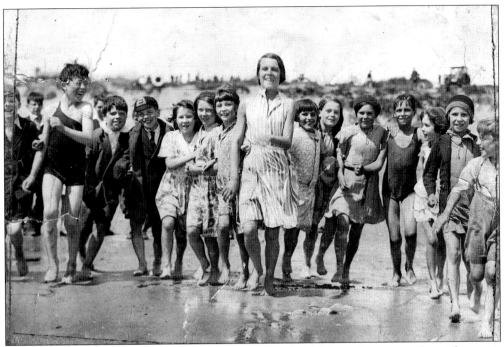

'Neath Poor Children at Port Eynon' on the Gower in 1920. The only name we know for sure is one Harold Rosser, who is the fifth child from the left.

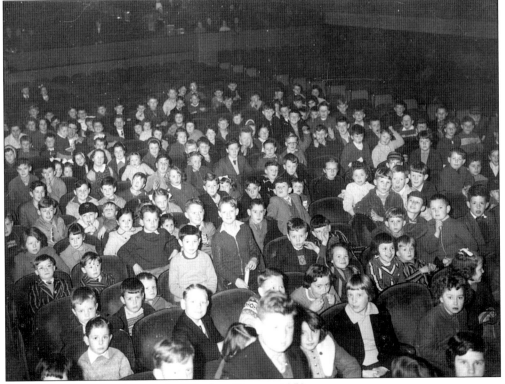

Saturday morning matinee at the Windsor Cinema, 1950.

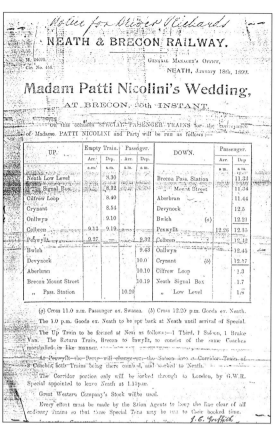

A rare Neath & Brecon Railway poster setting out the schedule for trains running from Neath to Brecon for Madame Patti Nicolini's wedding in 1899. Adelina Patti, the world famous opera singer, purchased Craig-y-Mos Castle (which was in fact a large mansion) with Nicolini in Swansea around 1880.

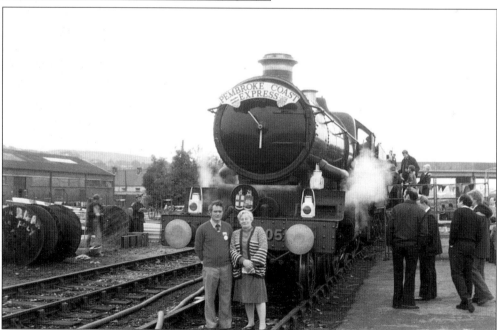

The *Dryslwyn Castle* came to Neath as part of the 150th year celebrations of the Great Western Railway in 1985. Pictured at the front is John Roberts of Neath Model Railway Club.

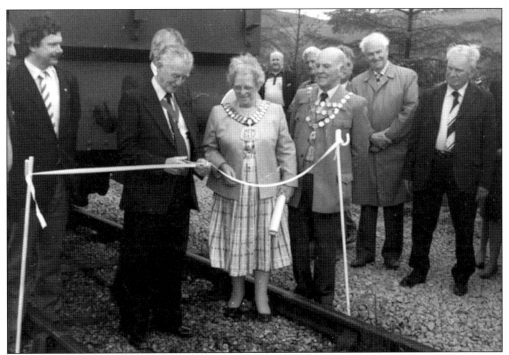

The handing over ceremony of the steam engine, *Pamela*, to the mayor of Neath, Cllr Iris Hobbs, in 1986/7. She received it on behalf of the Vale of Neath Railway Society.

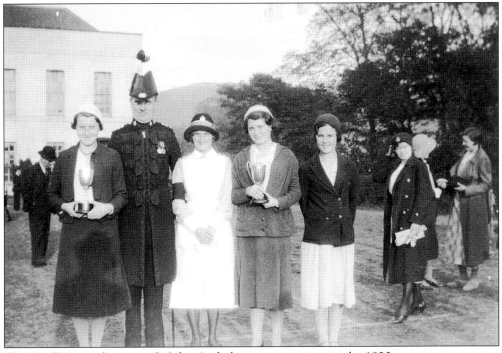

The Gnoll House, hosting a St John Ambulance presentation in the 1920s.

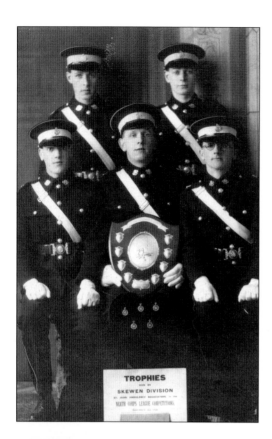

Members of the Skewen Division of St John Ambulance display the trophies they won in the Neath Corps League Competitions on 3 November 1928.

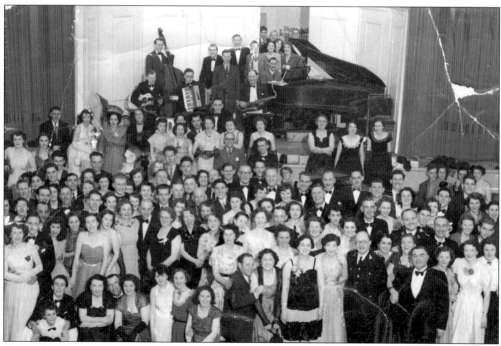

A St John Ambulance dance at Gwyn Hall in the 1940s.

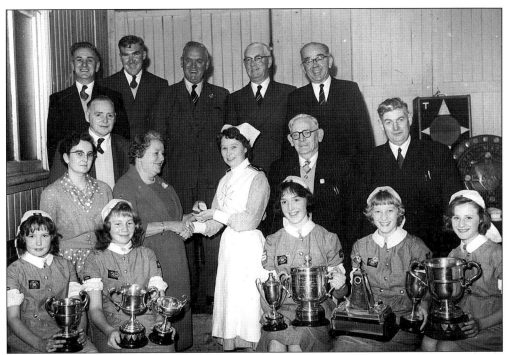

Presentation of awards to members of St John Ambulance at their Dynefor Road Hall in the 1950s.

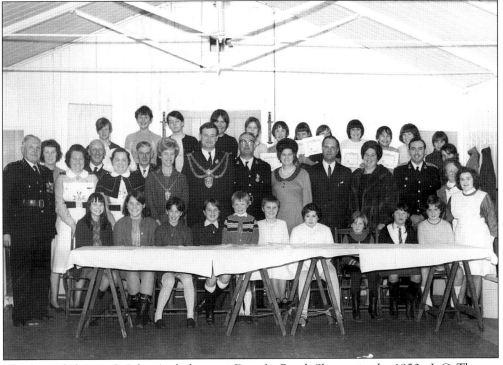

Members of Skewen St John Ambulance at Dynefor Road, Skewen in the 1950s. L.C. Thomas is wearing the chain of office. Also pictured are Beaty Thomas and Eleaza Rees.

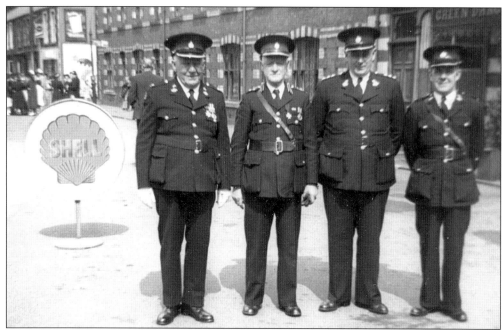

Four members of St John Ambulance pose on the forecourt of the Shell garage opposite the Green Dragon in Cadoxton in the 1950s. Eleaza Rees is standing second from the right.

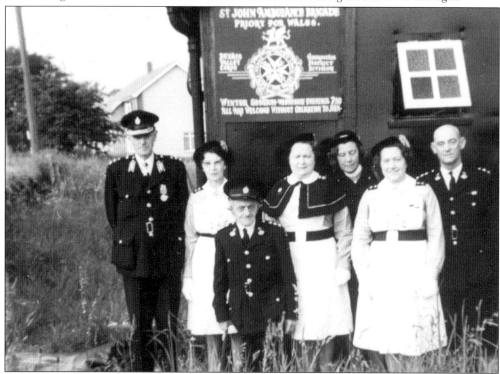

Outside the Cilfrew St John Ambulance Hall in the early 1960s. The hall was built in the 1920s and recently suffered from damage. Standing on the left is Eleaza Rees and Beaty Thomas is on the right.

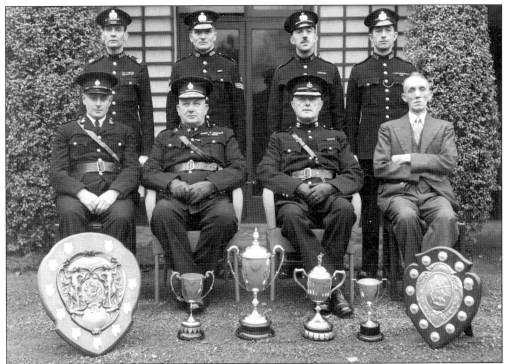

Glamorgan County Police, Neath Division, ambulance team, 1948/9. Left to right, back row: PC Gwyn Thomas, PS William Matthews, PC George Davies, PC Gwynfryn Evans. Front row, seated: Mr Eleaza Rees (instructor), Mr Joseph Jones CBE (chief constable), Supt William Doolan, Mr James Godsall (instructor). The trophies collected that year were, left to right: Glamorgan County Police Cup, Evans Beyan Cup, Glamorgan County Police Individual Cup, Vernon Hartsorn Shield, Dulais Valley Cup and the Dan Roberts Memorial Shield.

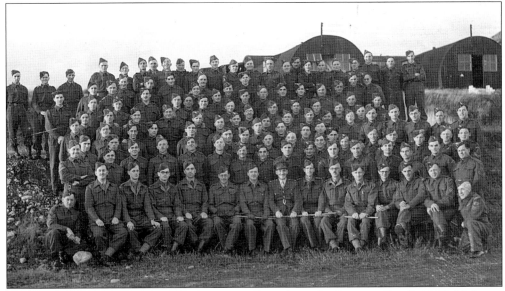

The Home Guard on the site of the Garnant colliery (now the Swansea Bay Gold Club), Jersey Marine, in the 1940s.

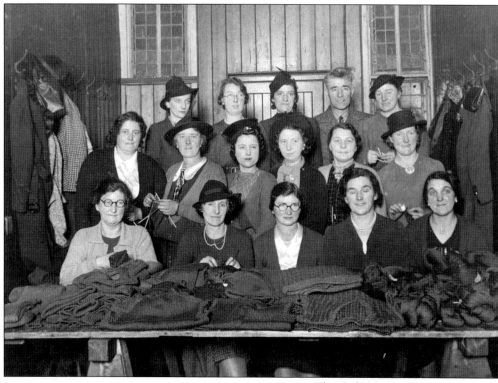

The Galv Works WVS members during the war effort, 1942.

HOME NEWS

Number 36, (Final Number). CHRISTMAS, 1945.
Organ of the
RESOLVEN AND DISTRICT COMFORTS FUND.
(A news-letter for our boys and girls in H.M. Forces).

A Merry Christmas. - Nadolig Llawen.

THE Comforts Fund Committee is on the point of winding up its activities. Consequently this is the final number of *Home News*, and our last opportunity of wishing you, through its medium, a Merry Christmas. Wherever you may be on December 25—in India, Palestine, Germany or at home—may your Christmas be a downright merry one. And may the New Year, too, be to you a happy one. The great majority of you are not yet demobilised, and are still "far from the old folk at home." This, we realise, makes you dissatisfied with your present circumstances. But circumstances are as changeable as the weather. If things are not right today, they may be quite different tomorrow. Remember, "It's a long lane that has no turning." And so, look forward optimistically—if you're not demobbed yet, you *will* be.

A Happy New Year.

Blwyddyn Newydd Dda.

THANK YOU.

SOME, at least, of the parental advice I received in my childhood still remains in my memory. My parents always advised me to say THANK YOU for any delicacy or kindness received. I have received numberless kindnesses from time to time, and my debt is very much indeed. Therefore—thinking primarily, at the moment, of the activities of the Comforts Fund Committee—I am now going to do a little thanking.

In the first place, of course, I must say that our little "homework," that is, our Committee-work, has been infinitesimal compared with the great sacrifices made and endured away from home by you—our gallant boys and girls of the Services. Still we had our little job to do; and as chairman, it is my duty to thank the happy band of workers I was privileged to have around me. Our work as a Committee—representing the public—was to keep in touch with you, and send you comforts. To the best of our ability, with the help of the public purse, and financial support from many local organisations, we have endeavoured through the long six years to carry out this work. The many scores of complimentary letters received from you lead

us to think that our work was done satisfactorily. We feel privileged to have had the opportunity of being of some assistance to you.

To all you boys and girls we give our united thanks, and a hearty cheer. The war over, we are expecting to see you all home soon. The local churches, and other excellent organisations, are awaiting you. When you return from your travels to be with your loved ones, Home will probably have a new meaning to you. But alas, all who went away will not return. Some have fallen in battle, and have found earthy and watery graves in distant parts of the world. In consequence there are awful rents in what used to be happy homes. Our profoundest sympathy goes out to those who mourn, and we "weep with those who weep." We pray that our Father above will wipe away every tear and bless the wives, parents, sisters, sweethearts and brothers among us who are in sorrow and distress.

Now may I be pardoned for returning for a little while to the Comforts Fund Committee. Our president, Councillor Mary Jenkins, gave us a grand send-off at the outset with very valuable financial support. Her example was followed by other well-known ladies and gentlemen of the village, and by various organisations, and the free public throughout has given us unflinching and continued support. Unfortunately we lost our first chairman—the late Councillor D. J. Evans. We missed his happy countenance greatly. We were also unfortunate in losing through death three other stalwarts, namely Mr. J. F. Bristow, Mr. Ben Richards, J.P., and our esteemed vice-chairman, Mr. T. W. Herbert. We very much felt the loss of these staunch advisors in our deliberations. The Miners' Welfare Committee always placed cosy rooms at our disposal gratis. There we met in committee, and there our Lady Knitters—who, year in and year out, have made it possible for us to carry on—met regularly each week. I do believe that the ladies dropped many pearly tears into the parcels that were sent you. Our treasurer, Mr. E. Jenkins, B.A., was an excellent chancellor. Even Demas, of Biblical history, could not have kept a keener watch on the bronze copper, and given more exact financial reports. But I will not offend anyone, I am sure, when I say that the bulk of the work has been carried out by our secretary, Miss A. Millicent Rhys. She has been kept in full employ—filling up thick minute books, replying in committee to inquiries about this and that, and writing hundreds and hundreds of letters. Always courteous, Miss Rhys contributed greatly towards making us such a happy band.

Home News produced by the Resolven and District Comforts Fund. This was the last issue of the magazine. They would have meant Blwyddyn Newydd Dda, which means 'Happy New Year'.

118

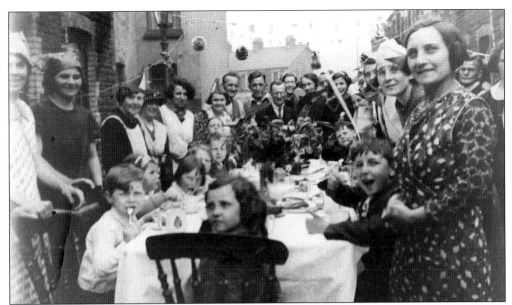

Celebrating the Coronation of George VI in Alice Street Neath, 1937. Included are: Gladys Davies Edward Davies, Gwyneth May Williams.

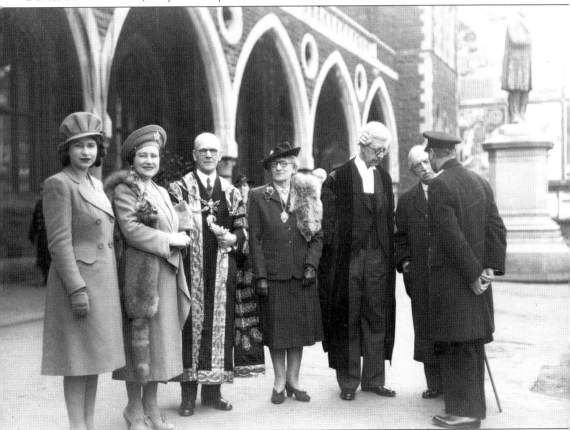

A pre-war royal visit to Neath.

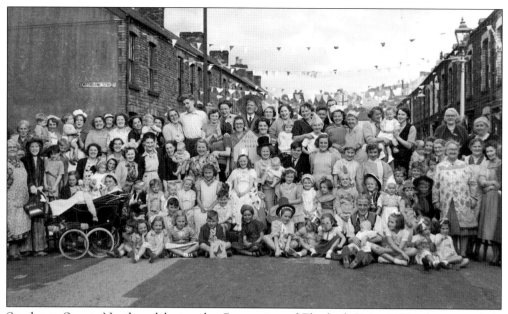

Southgate Street, Neath, celebrates the Coronation of Elizabeth II in 1953. The young lady wearing the crown in centre was Festival Queen in 1951. Note Kempthorne Street on left.

The home of Joe Thomas, 21b Southgate Street, suitably decorated to celebrate the Coronation in June 1953.

Seven
People

Taking a break from hay making in Cae Dafydd, Longford, 1967. Left to right: Boyd Foster (obscured), -?-, Morgan Price, -?-, William Morgan, Howell Price, Royston John.

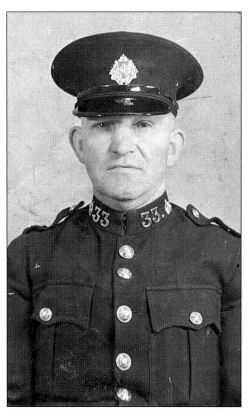

Sergeant Hugh Roberts, the last mounted policeman in the Neath Borough Police. Inevitably, cutbacks and the increased use of the internal combustion engine meant that it was no longer viable to keep horses for use in Neath. However, they would still, on special occasions, hire a mount for Sergeant Roberts to ride. Sgt Roberts served Neath Borough from 1920 to 1947, seeing out his service in 1951 with the Glamorgan Constabulary.

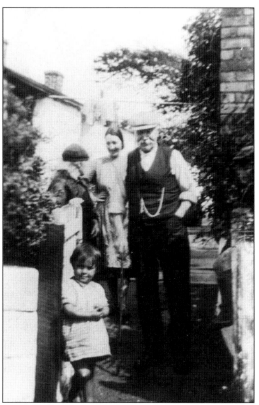

Mrs Evelyn Price (centre) flanked by Mr and Mrs George Morgan at the front of Longford Farm, 1931. In front is a young June Price.

The back of the Wyndham Arms, Mackworth Lane, Neath, *c.* 1950. The Wyndham was in the area where the Iceland store is today.

The Moore family of Maes Mawr, Crynant, *c.* 1936. Left to right, back row: Glan, Minnie, May, Annie, Morfydd. Front row, seated: Olwen, Edwin (father), Royston, Maggie (mother), Jim.

The Isle of White Farm, Tonmawr, in 1885. Left to right: Thomas Price, Moriah Parker, Margaret Price, Ann Magdalen Price (the local midwife). The child in foreground is Thomas Price Jnr.

A firemen studying the rule book prior to exams outside Cwrt Sart loco sheds, c. 1950. In the picture are Malcolm Powis and Gwyn Richards.

Gladys Hopkins (*née* Price) at the age of six outside 10, Blaenavon Terrace, Tonmawr, in 1901. Gladys was 103 years old when she died in 1998.

Elizabeth Hopkins at Tonmawr Farm, 1920.

Three sisters sit on the tractor at hay making at Longford Farm, 1947. Left to right: June Price, Elizabeth Price, Mona Price.

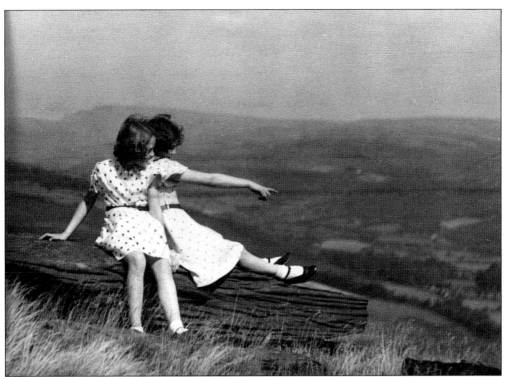

Barbara Griffiths and Jean Walker
looking down on Neath from
Mynydd March Hywel in 1930.

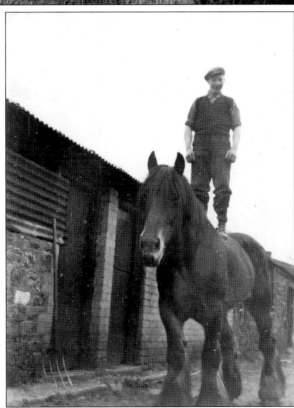

David Morgan Price at Longford
Farm in the 1950s.

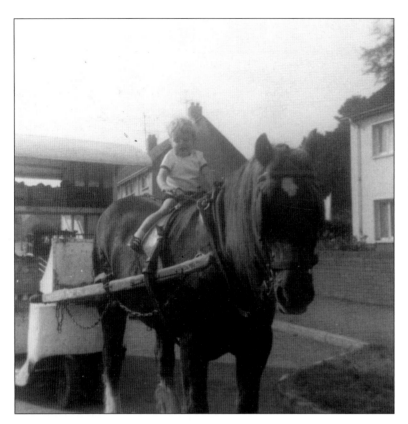

Ian Hillman of Rhydhir hitching a ride with one of the last horse drawn deliveries in the Neath area. Walter Price & Sons of Longford Farm delivered milk with their horse Champion well into the 1970s.

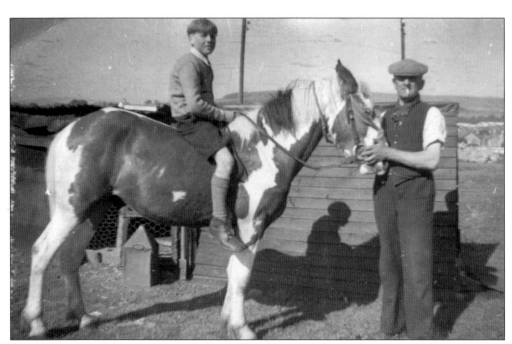

Harold Courts and Alan Smith with their piebald horse on Cimla Common, 1945.